CONTENTS

ACKNOWLEDGEMENTS

The author extends his sincere thanks to those who have helped him in compiling this book. They are Pat Donovan, Brian Martin, Pamela Needham, Ray Puddifoot, Sir John Randall, Avice Turner and Robert Wright. Carolynne Cotton and Paul Davidson in the Local Studies section of Uxbridge Library have given every assistance over a long period. The author is also deeply indebted to his wife Pam, who has helped at every stage, and his daughter Gill Clark, who prepared all his material for the publisher.

This document, dating from around 1180, gave the people of Uxbridge the right to hold a market every week on a Thursday.

UXBRIDGE AT WORK

KEN PEARCE

AMBERLEY

First published 2017

Amberley Publishing
The Hill, Stroud
Gloucestershire, GL5 4EP

www.amberley-books.com

Copyright © Ken Pearce, 2017

The right of Ken Pearce to be identified as the Author
of this work has been asserted in accordance with the
Copyrights, Designs and Patents Act 1988.

ISBN 978 1 4456 7084 3 (print)
ISBN 978 1 4456 7085 0 (ebook)

British Library Cataloguing in Publication Data.
A catalogue record for this book is available
from the British Library.

Origination by Amberley Publishing.
Printed in the UK.

INTRODUCTION

The origins of Uxbridge have been traced to a Saxon tribe called the Wixan, who came and settled by the River Colne. Eventually a bridge was built there across the river, which became known as the Wixan-bridge. It took centuries before the spelling evolved to become Uxbridge.

In the second half of the twelfth century, a new town was laid out nearby on higher ground. Strips of land, or burgage plots, were marked out on either side of the London to Oxford road. The destiny of the town was settled when Gilbert Basset, the then Lord of the Manor, obtained permission from Henry II to hold a market there every Thursday. The document reporting this is known today as the Basset Grant, and is the most prized possession in the Hillingdon Borough Archives. The market flourished, and the town became the trading centre for much of west Middlesex and south Buckinghamshire. Corn was the principal commodity and flour mills were established on nearby rivers, where the grain could be immediately processed.

In the fifteenth century a man called John Fray implemented a scheme to divert some of the Colne Water into a nearby tributary, thereby increasing the flow of water. This became known as Frays River, and more flour mills were opened along its banks.

The market grew in the eighteenth century, so that the existing Market House that had been built in 1561 was hopelessly inadequate. The town's leaders therefore commissioned a larger market building, which was ready for use in 1789. At the time it was by far the biggest building in the town, and it heralded a period of prosperity that lasted for over half a century. By then Uxbridge had become one of the largest corn markets in the south of England. On one particular day, 2,752 sacks of corn were brought in to be sold. Local mills were now supplying much of London's flour, and a cattle market was opened as well. Stalls along the High Street were selling farm produce each market day.

This was also the great age of the stagecoach, and since the town lay on the high road between London and Oxford, there were coaches passing through from dawn to dusk. Coaching inns prospered, offering food, accommodation and a change of horses. Many local people found jobs in the coaching trade.

Another factor was the opening of the Grand Junction Canal, which linked the Thames at Brentford with the Midlands canal system in Northamptonshire. The section from Brentford to Uxbridge was ready in 1794, with the whole scheme completed in 1805. Wharves and

warehouses were built along its banks, and corn, timber, slate, coal, bricks and tiles were transported to and from the district.

The advent of the railways changed everything as Uxbridge was not on a main line. Fast and smooth-running trains soon replaced the uncomfortable and slow-moving stagecoaches. Local growers found that they could make a more profitable income from market gardening and fruit-growing rather than corn. The weekly market continued, but the corn rapidly disappeared.

Two significant events took place in the summer of 1904: the Metropolitan Railway opened a branch from Harrow to Uxbridge, and the London United Tramways ran their electric cars from Shepherds Bush to the town. These were signs that London was spreading out and that the market town of Uxbridge would slowly turn into a suburb. At the same time electricity became available, and promoted industrial development.

In 1917 the Hillingdon House estate on the outskirts of the town became the Armament and Gunnery School of the Royal Flying Corps. In 1918 the corps was renamed the Royal Air Force, and local people found employment at the station for the next ninety years.

Between the wars commercial and residential schemes continued. The Bell Punch Co. and Sanderson's Fabrics arrived, and the film studios that opened at Denham and Pinewood offered more jobs. The cut-flower nursery of Lowe and Shawyer provided work for several hundred employees on its 200-acre site.

Recovery was slow in the years after the Second World War, but accelerated in the 1950s. The conservation movement came too late to save many of the town's historic buildings, and whole parts of the area were rebuilt. The proximity of Uxbridge to Heathrow Airport and to three motorways has led to enormous office development and numerous industrial estates.

Brunel University sprang up on the former nursery land and, more recently, Bucks New University has opened a department here.

At the present time, office blocks built a mere thirty years ago are being refurbished and modernised. The prosperity of the district can perhaps be judged by the proliferation of food and drink outlets, but here and there one can glimpse traces of the town's history.

THE EARLY YEARS

THE MARKET HOUSE

For over 700 years Uxbridge was a market town and the nucleus of a rural community. The market served west Middlesex and south Buckinghamshire, but it is recorded that from time to time wagons laden with corn came from places as far away as Hendon, Edgware, Hounslow, Hampton, Missenden and Chinnor. It wasn't until the mid-nineteenth century that the corn trade declined and the market centred on farm produce. The Market House remained the focus of all activity.

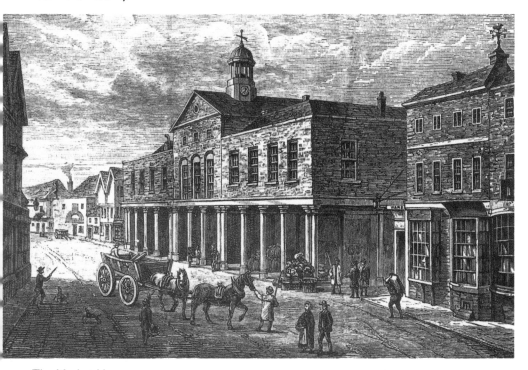

The Market House.

THE HIGH STREET

This drawing shows the street around the year 1800. The Market House is prominent and on the left is the Kings Arms Inn – wrongly labelled the Kings Head. A pavement has been laid and there are street lamps lit with vegetable or fish oil.

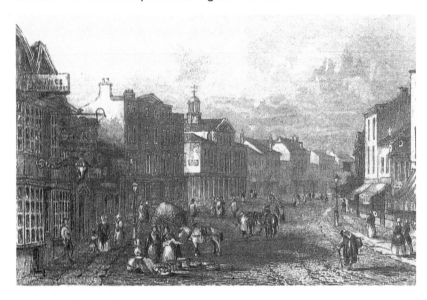

The High Street.

WINDSOR STREET

Apart from the main street, this road off to the south was the only other commercial thoroughfare. The name probably dates from around 1800, when it was paved and lit. Before that it was known as Catsditch or The Lynch. (The latter is a word meaning 'slope'.)

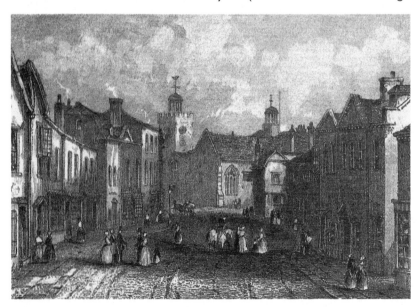

Windsor Street.

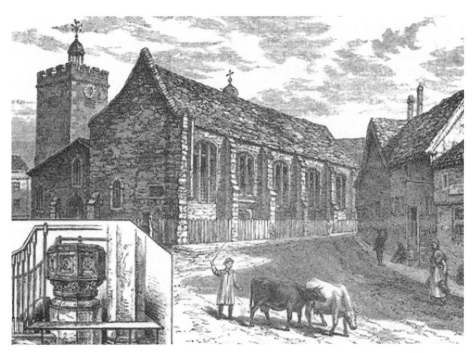

This illustration of Windsor Street is taken from the first written history of the town, which was published in 1818. The authors were George Redford, a clergyman, and Thomas Riches, a solicitor. The parish Church of St Margaret dates mostly from the fifteenth century.

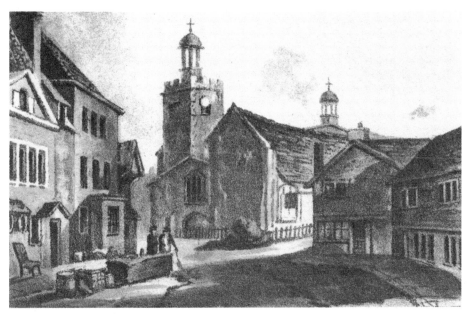

Another view, but by a less gifted artist. The turret of the Market House can just be seen over the church roof. Church and Market House sit next to one another on a very crowded site, perhaps symbolising the spiritual and material aspects of life.

MARKET HOUSE

Market House was completed in 1789 at a cost of £3,000. Fifty-one wooden columns support spacious rooms and a clock tower above. The ground floor was completely open, for that was where the corn was pitched on market day.

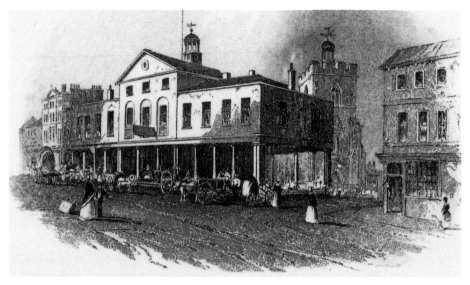

Market House and Church.

THE WESTERN APPROACH

Another 1818 illustration showing the entry into the town from Bucks. High Bridge is on the right. An earlier version of this bridge on the same site gave the town its name. On the left is the Swan Inn, now known as the Swan and Bottle.

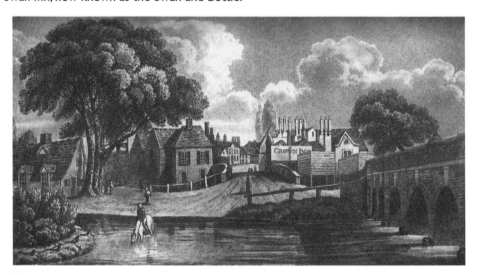

Scene over the river.

STAGECOACHS AND COACHING INNS

The town's position on the old Oxford road meant that it became a coaching town and a place where horses could be changed.

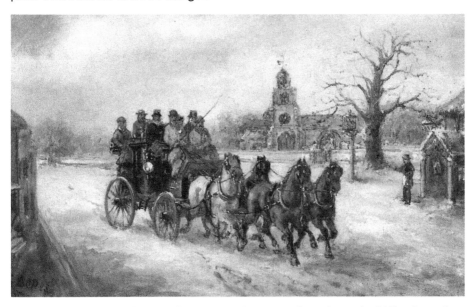

This painting by Henry J. Jones shows a coach passing through nearby Hillingdon village.

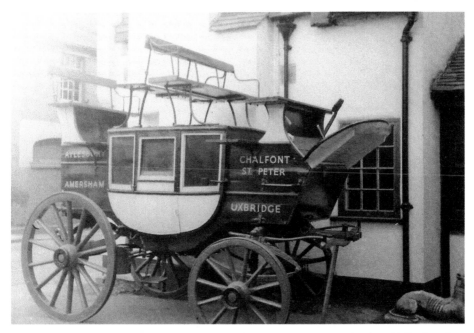

This Aylesbury–Uxbridge coach has survived and was photographed in 1963. Coaches were usually named, and this one was called *Vivid* – perhaps because of the black and yellow paintwork.

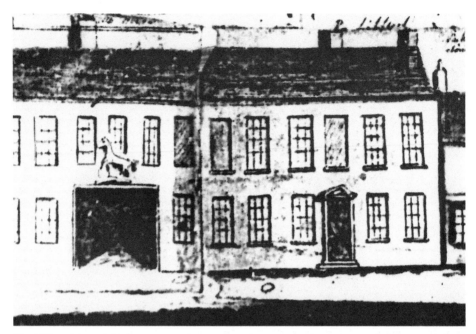

The White Horse, the largest coaching inn in the town, is shown here in this pen-and-ink drawing of the High Street from around 1800. A model horse sits over the main entrance. When the building was demolished *c.* 1850, the yard was opened up to become Belmont Road and an outbuilding became the White Horse public house. It is now a branch of Prezzo.

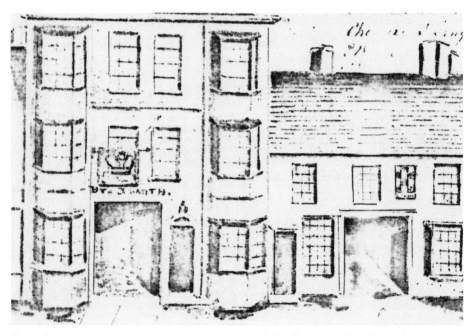

From the same source we see the Crown Inn and the Chequers Hotel on adjacent sites. The Crown did not last long after this, but the Chequers survived until 1960 (see page 61).

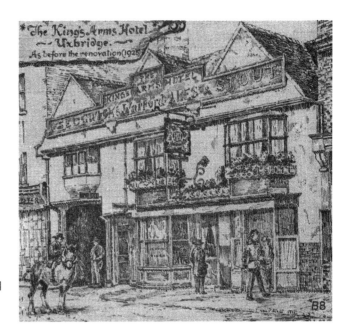

The Kings Arms Hotel is yet another old inn, but this one still stands. It remained an inn until 1960, when it finally closed and became a restaurant. The venture failed and since then it has been used as offices.

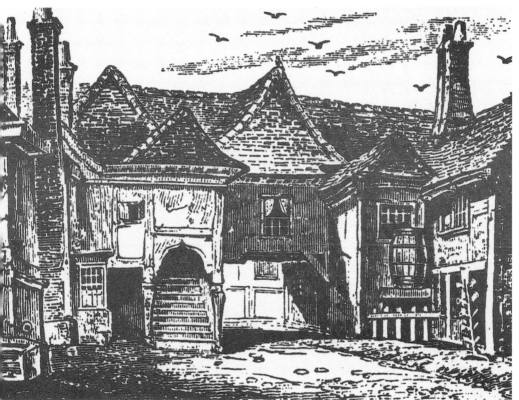

Originally the George and Dragon, the George Inn was yet another coaching inn. The coaches would pull into the spacious yard, where there were stables and other outbuildings. A fine staircase led to accommodation for travellers.

FRAYS RIVER

Partly natural, and partly man-made, it takes its name from John Fray (see Introduction). It leaves the main stream of the Colne in north Denham and rejoins it at West Drayton.

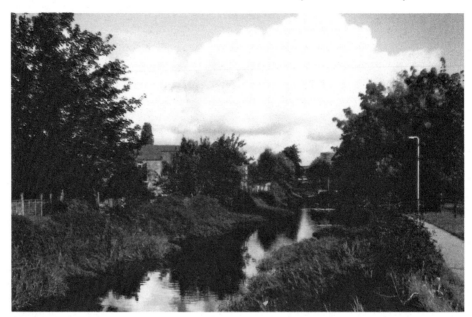

A section of the river today.

RABB'S MILL

Rabb's Mill in Cowley Road was made possible by John Fray's plan. Its name has changed as owners have come and gone, but earlier names include Austin's Mill and Dobell's Mill. A fire in 1928 ended its days as a mill, but part of the structure is still standing.

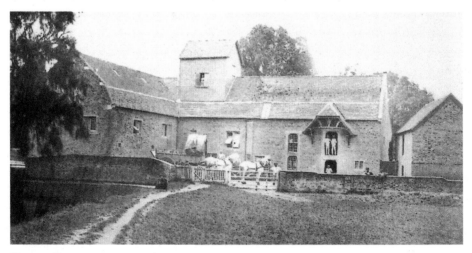

Flour mill.

GRAND JUNCTION CANAL

At the end of the eighteenth century, the cutting of this canal brought economic growth to the district. Bulky goods like coal, timber and bricks could be carried better on water than on land.

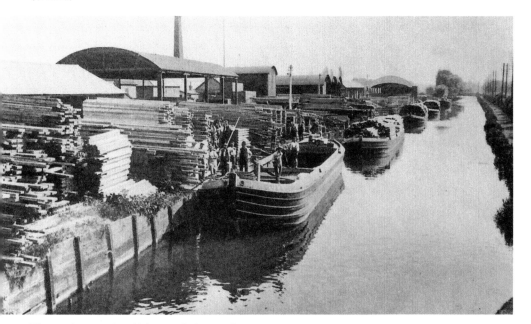

The timber yards of Messrs Osborne Stevens.

PADDINGTON PACKET BOAT

This public house at Cowley is a reminder that when the canal was first opened, Londoners were offered day trips to the countryside of West Middlesex. The project did not last long, but surprisingly this place of refreshment has never been renamed.

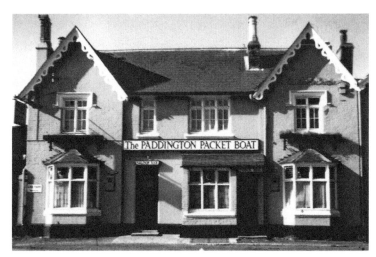

Paddington Packet Boat.

AN UXBRIDGE CHAIR

In the late eighteenth century a firm was established in the High Street making Windsor chairs. The example seen here, held in the borough archives, shows the characteristic three splats in the back hoop. An Uxbridge chair is a valuable antique today.

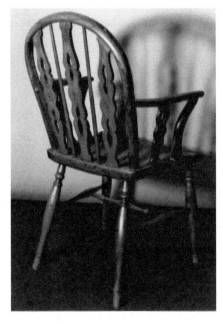

An Uxbridge chair.

THE CHAIR FIRM

This bill survives in the borough collection. The company was founded by John Prior, who seems to have come from the Windsor area and settled in the town. He was succeeded by his son Robert.

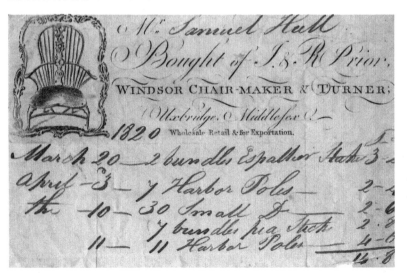

The chair firm's bill. (Courtesy of Hillingdon Heritage Services)

THE VICTORIAN AGE

The population's standard of living rose markedly over the course of Victoria's reign. This was in no small part due to the local Board of Health, which was established in 1848. In the ensuing years, a reliable supply of clean water became available and proper drains and sewers were laid. The general health of the people improved, and the average life expectation rose as a result. In 1894 the Board of Health was replaced by the Urban District Council, which in turn improved the town's facilities. In 1856 the town was linked by a Great Western Railway branch line, and goods traffic enhanced the commercial scene.

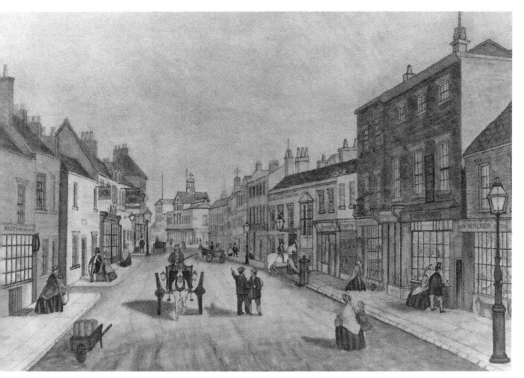

Uxbridge High Street, 1850.

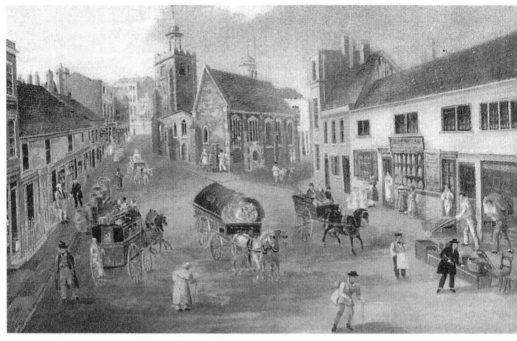

This charming painting of Windsor Street from around 1850 is thought to be the work of a Liverpool artist named Thomas Gell, who was staying with relations in the shop on the right. It catches the bustle and activity of the market town very well.

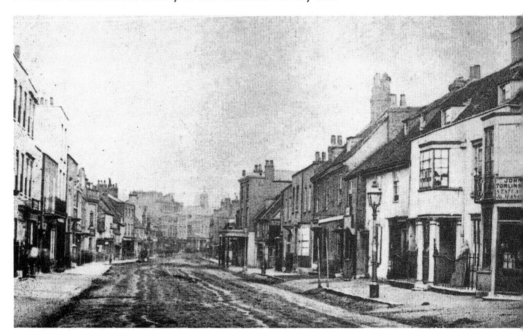

An old photograph reveals the poor surface of the main street, but at least there are good pavements and gas lighting. Gas was introduced in 1836 by an Irish engineer called James Stacey, who was not related to the family on page 21.

OSBORNE STEVENS & CO.

This timber firm was set up in 1760, but the opening of the canal transformed a small local business into a large operation. Their canalside premises were near the western end of the High Street.

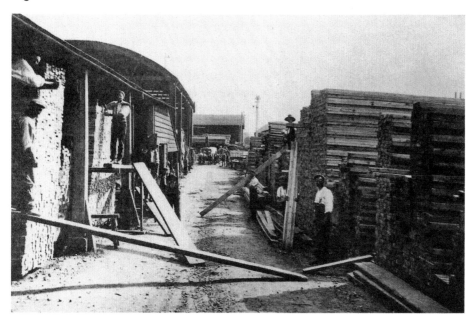

Timber yard.

TIMBER YARD

Large quantities of timber were stored on arrival, left to dry, and then were sawn and planed. In the early days the timber came from other parts of the country via the Thames, but later wood was imported – notably from Norway and West Africa.

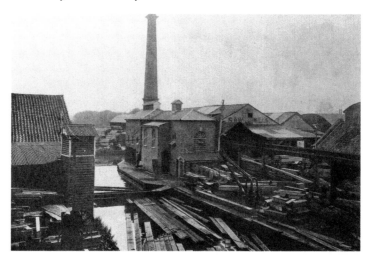

Timber yard – note the chimney.

GILES HUTSON (1823-1904)

Giles was a saddler and harness-maker in the High Street. In later life he wrote about his childhood in the 1830s, which is a valuable record of life in the town at that time.

Giles Hutson.

CHARLES HALL (1820-53)

Charles owned a grocery shop in Windsor Street, and by the time he was twenty-six he weighed 26 stone. He died in his bedroom aged thirty-three, and his enormous body was passed out of the window on to a hay cart below.

Charles Hall.

ALEXANDER MITCHELL (1847–1905)

Alex's shop was in Hillingdon village, and had been in his father's ownership before that. He played a prominent part in the life of the community.

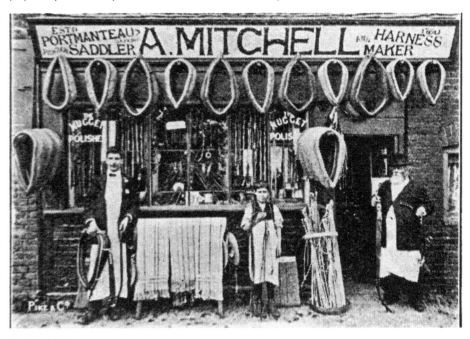

Saddler's shop.

GEORGE AND MARTHA STACEY

George's father, James Stacey, came to Uxbridge in the early nineteenth century and established a brass and iron foundry in the town. George assumed control after his father's death. The yard that led from the High Street to the foundry was eventually named George Street.

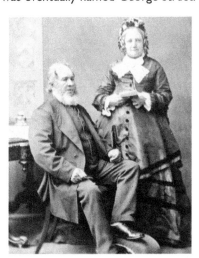

George and Martha Stacey.

FOUNDRY PRODUCTS

UXBRIDGE IRON FOUNDRY

AND

AGRICULTURAL IMPLEMENT

MANUFACTORY,

Established Half-a-Century.

GEORGE STACEY & SONS,

IRONFOUNDERS, ENGINEERS,

SMITHS, AND MACHINISTS:

MANUFACTURE STEAM ENGINES,

THRASHING AND WINNOWING MACHINES,

TURNIP CUTTERS, ROOT PULPERS,

Mills, and Chaff Cutters for Hand or Horse Power, and every other Implement required for the Farm.

PLOUGH IRON WORK OF ALL KINDS.

CASTINGS IN IRON OR BRASS

AT LOWEST PRICES.

Left: The 1865 advertisement seen here shows that the main trade was in agricultural implements, but the Uxbridge Iron Foundry also produced stoves, kitchen ranges and other household implements. George also invented a sausage-filling machine.

Below: Victorian houses usually had iron gates and railings made at the foundry, but most were removed during the Second World War when metal was needed for munitions. This splendid patriotic example in Cowley Road managed to survive.

RETAIL OUTLET

A section of the High Street can be seen here around 1870, showing that the foundry had a shop selling their wares. Photographs needed a long exposure in those days, which is why someone walking along the road has almost disappeared.

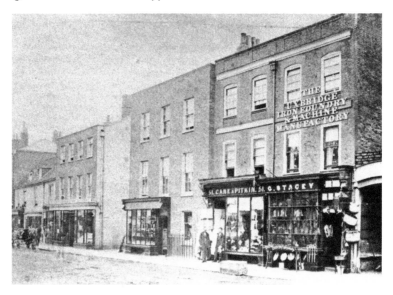

High Street,
c. 1870.

OLD PUMP

George Stacey built a row of cottages for his workers in York Road, which he called Foundry Terrace. When they were demolished in 1935 this old pump was still standing. It would have been made at the foundry.

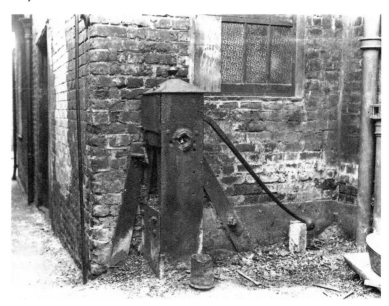

The old pump.

WATERWORKS

The Local Board of Health established the pumping station seen here, off Waterloo Road, in 1866. Until then people had relied on pumps and wells, but now pipes were laid to give a much improved supply. It was forty years, though, before the town had a constant and reliable supply.

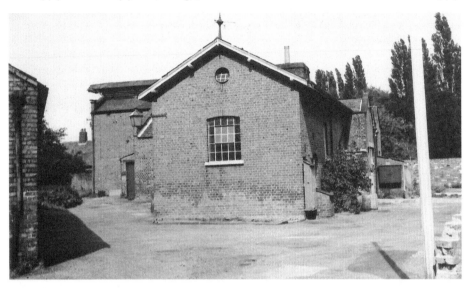

The pumping station off Waterloo Road.

CARRICK AND COLES

In 1868 a small High Street drapery store was purchased by Albert Carrick and Joseph Coles. They set about rebuilding the premises, and their splendid new store, ready in 1871, was called Waterloo House. It was the largest shop in the town.

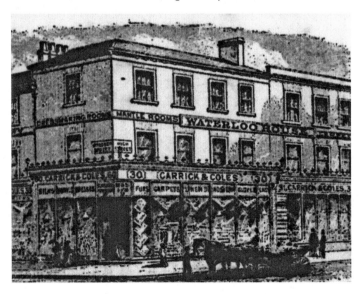

Carrick & Coles.

VINE STREET STATION

The main line of the Great Western Railway passed through West Drayton, but Uxbridge was not on a rail link. After twenty years of complaining, the GWR gave in and opened a branch line in 1856. The station is shown here on the right-hand side of the road.

Passenger trains on the branch line were able to connect people with London. Goods trains brought more commercial activity. The stationmaster, Alfred Pearman, is shown with clerks, porters and shunters.

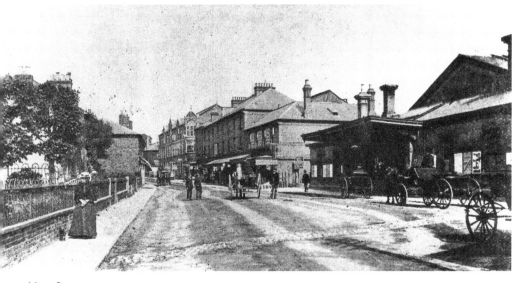

Vine Street.

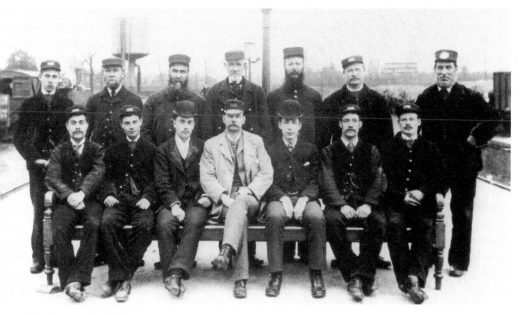

Station staff in 1892.

LENO'S STORE

James Leno (1841–1916) was a member of a very well-known Uxbridge family. He opened his Windsor Street shop in 1887, and the advertisement shows that he was involved in a variety of activities. He described himself as 'universal provider'.

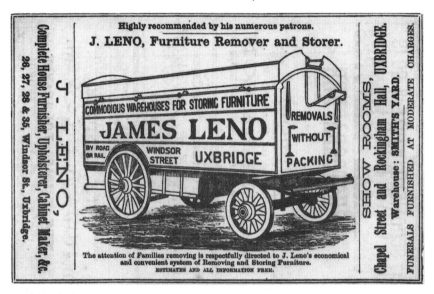

An advert for 'J. Leno, Furniture Remover and Storer'.

BROWNIE'S

This firm was established by Wrightson Brownie in 1828 and traded in ropes, sacks, rick cloths and other items for farmers. As they were official suppliers to the royal farms at Windsor, they were entitled to have the royal coat of arms above the door. They also hired out tents and marquees.

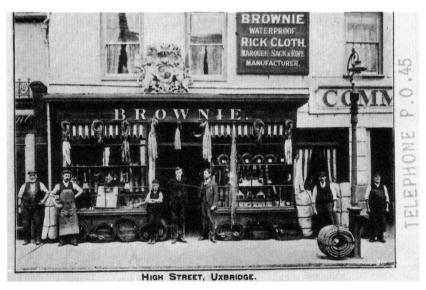

Brownie's shop.

RANDALL'S STORES

William and his brother Philip owned and ran a furniture and upholstery business in High Wycombe, but in 1891 they purchased a store in Vine Street. William ran this for some years, while Philip remained at Wycombe. In due time the Wycombe business was sold, and Philip joined his brother in Uxbridge. They made it the largest furniture store in the town.

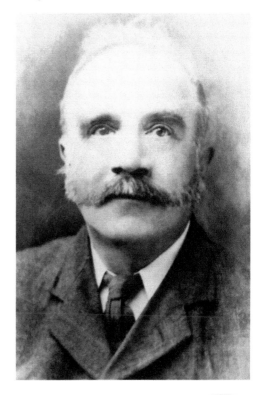

Above left: Philip Randall (1862–1922).

Above right: William Randall (1868–1936).

Right: The original Randall's store, seen here, next to the railway station.

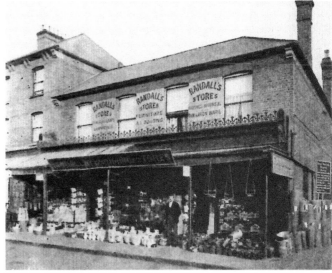

FIRE AT UXBRIDGE

The Uxbridge Volunteer Fire Brigade was set up by the local Board of Health in 1864, with headquarters in Windsor Street. The men were all volunteers, although their uniforms and equipments were supplied. The horse-drawn Merryweather appliance seen here was bought in 1881.

Fire broke out at Rabbs Mill in February 1898. Despite the efforts of the local fire brigade, the mill was destroyed; however, it was soon rebuilt.

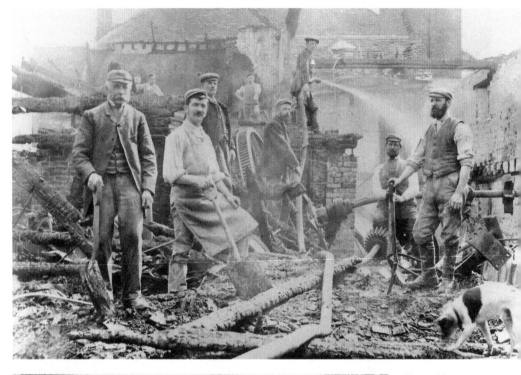

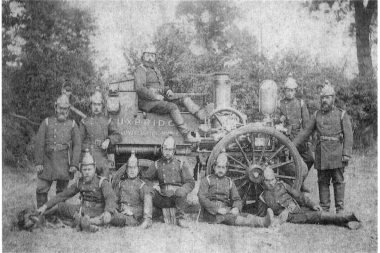

Above: Here we see employees and firemen searching the debris at Rabbs Mill for anything that might be saved.

Left: Uxbridge Volunteer Fire Brigade.

BUTCHERS AND BUILDERS

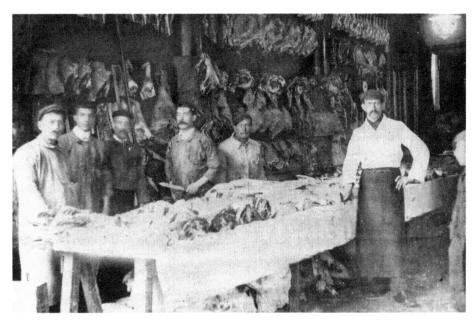

The stall in the Market House seen here was started by the brothers George, William and John Lintott in May 1870, and was run continually by family members until 1963. During this period there was no refrigeration, and less awareness of hygiene.

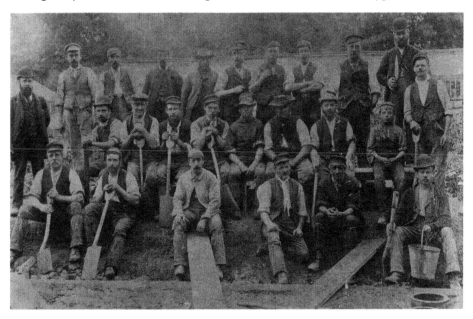

This group of men were photographed at Harefield Place in around 1900. The men in bowler hats are clearly in charge, and some workmen are carrying tools showing their particular trade.

UXBRIDGE'S ROADS

The state of the roads in the Victorian period left much to be desired, especially in wet weather. Potholes and puddles were everywhere. Men were therefore employed to try and keep road surfaces dry and level.

In 1896 the Uxbridge Urban District Council purchased a 10-ton steam-roller from A. J. Ward of Egham, and road maintenance soon improved. In 1902 the High Street acquired a proper tar surface for the first time.

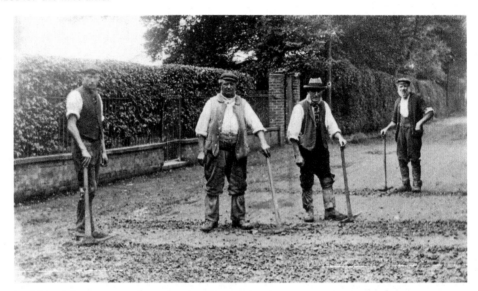

Road-menders.

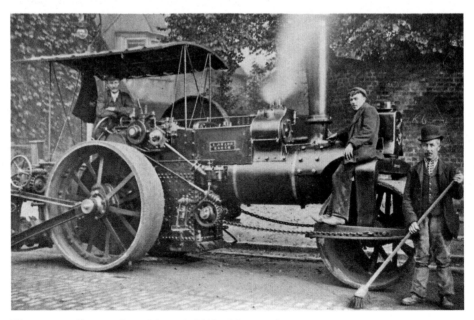

The steamroller purchased from A. J. Ward for road improvements.

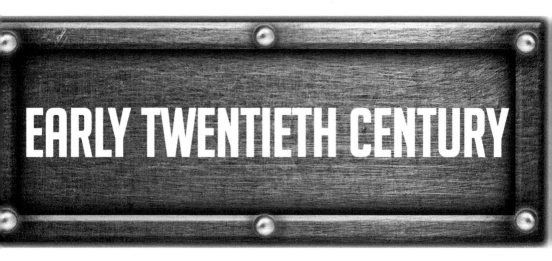

EARLY TWENTIETH CENTURY

The row of old shops and public houses opposite the Market House give the impression that Uxbridge had been left behind in the march of progress. Things were about to change dramatically. In 1904 the Metropolitan Railway opened a branch from Harrow, and in the same year the electric cars of the London United Tramways ran through the street. An electricity company was established, telephones became available and the first motor cars were to be seen. These developments heralded the change from country town to London suburb.

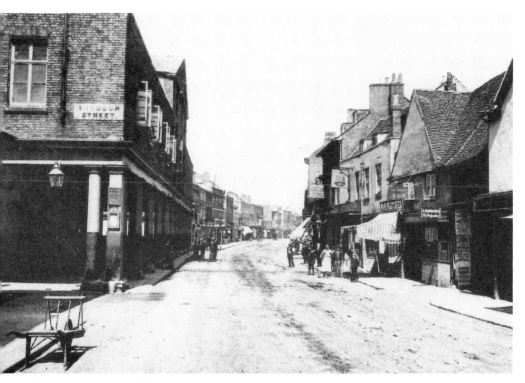

The town centre c. 1900.

RABBS MILL

Destroyed by fire in 1898, the mill was rebuilt and continued to produce flour. Another disastrous fire in 1928 finally brought milling to a close, but part of the building survives as the Hale Hamilton factory in Cowley Road. In the early years of the century the mill was run by Frederic Dobell.

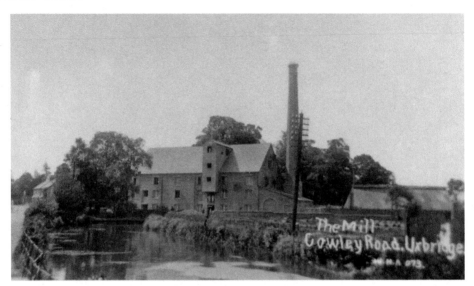

Rabbs Mill.

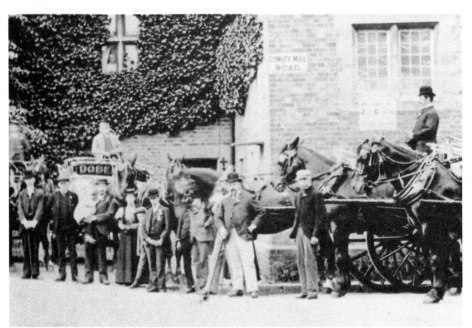

Here we have the staff and their families about to go off to Burnham Beeches on their annual summer outing. Mr Dobell is wearing a bowler hat and light trousers.

ELECTRIC TRAMS

On 31 May 1904 a photographer on the roof of the Market House took this shot of the first tram arriving in the town. Crowds came out, and flags were flown to mark this notable event. The service was numbered Route 7.

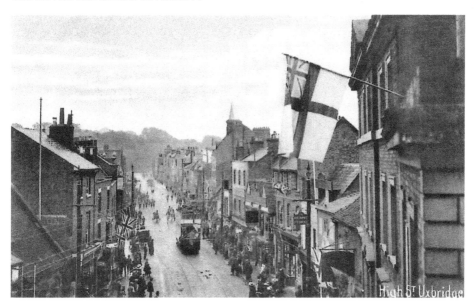

The first tram to arrive in Uxbridge.

STEAM TRAINS

On 30 June 1904 the first Metropolitan train steamed into Belmont Road station from Harrow with railway officials and invited guests on-board. The company had hoped to run electric stock from the start, but the system was not ready. For the first six months steam locomotives were used.

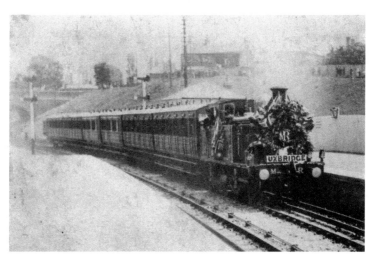

The coming of the railways.

ELECTRICITY

The Uxbridge & District Electricity Supply Co. was formed in 1901 and a generating station was built by the canal off Waterloo Road. A limited supply became available in 1902.

Men were employed to dig up the roads and lay cables from 1901, which was a major operation. The company offered free installation to customers, who paid for their supply by coins in the slot.

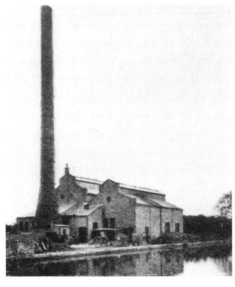

Left: The Uxbridge generating station.

Below: Employees of the company.

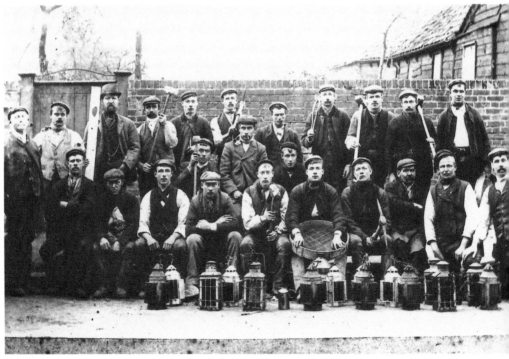

RANDALL'S

Randall's moved their furniture department to this new store in Vine Street in 1900. It was the first shop in the town to have electric power, which came from their own generators and not the electricity company.

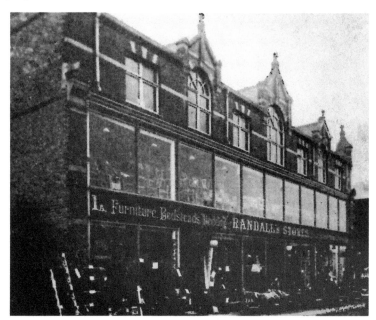

The new Randall's store in Vine Street.

CARRICK AND COLES

This remained the largest store in the town, and was run on very traditional lines. Customers were met at the door by a shopwalker, who directed them to the correct department. Money was sent to a cashier by an overhead railway system.

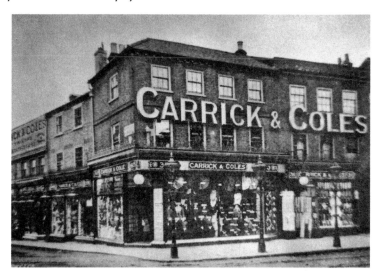

Carrick & Coles.

TELEPHONES

In 1901 the National Telephone Co. opened an exchange in Vine Street, and their service began in 1903. By the time the company merged with the Post Office in 1912, there were 164 subscribers.

The honour of having the number Uxbridge 1 went to William Coad, the owner of a drapery and furniture store in the High Street. If you asked for Uxbridge 5 you got Dobell's Mill. The police station was Uxbridge 9.

Left: Engineers laying cables in the High Street.

Below: The first telephone number, 'Uxbridge One'.

'Phone: **Uxbridge ONE** Terms: **CASH**

COAD'S
of UXBRIDGE

(Suters Ltd.)

Drapers, Art Furnishers and Ladies' Complete Outfitters, etc.

AGENTS FOR LOTUS & DELTA SHOES

159, 160 & 161 HIGH STREET
UXBRIDGE

FLOWERS

To the south of the town was this large cut-flower nursery, founded by Joseph Lowe in 1864. He was joined by George Shawyer in 1897. The firm specialised in chrysanthemums and roses. By 1914 their site covered 71 acres and there were 300 employees.

At this period renowned rose grower Edwin Alford developed several new varieties. His great success was Lady Hillingdon, a peach-coloured rambler that won the gold medal of the National Rose Society in 1910. It is now also available in bush form.

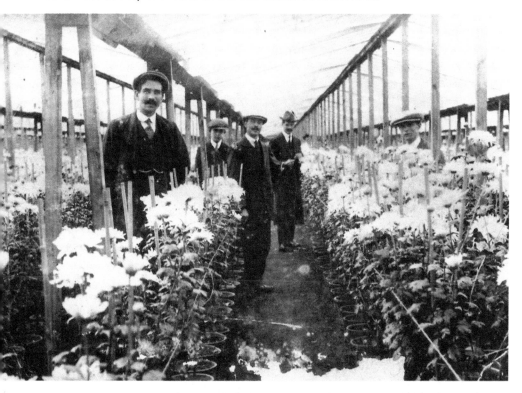

Above: Lowe & Shawyer.

Right: The Lady Hillingdon rose.

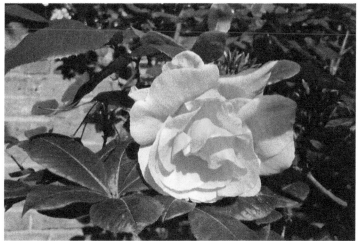

A RURAL CRAFT

John Barnett (1857–1938) was the last hurdle-maker in Uxbridge. Self-employed, John used willow and birch in his workshop. He was still working in 1913, but the district was changing and demand was falling away. He later worked as a gardener.

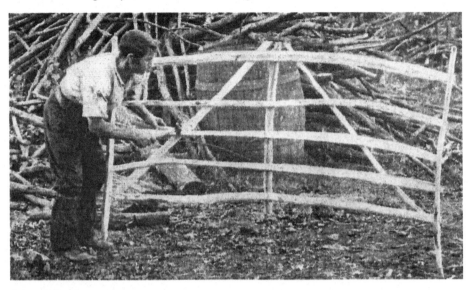

A hurdle-maker.

COSY TEAROOMS

The owners of Cosy Tea Rooms were Sam and Lucy Mutters. Earlier in life Sam had toured the country using the stage name Little Sam Waller. He was a juggler, clown and pantomime player, but retired to run this small business.

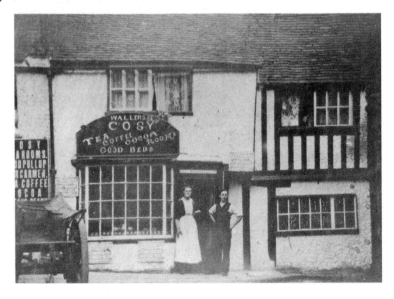

Sam and Lucy Mutters stand at the door of their Windsor Street tearooms.

LOCAL NEWSPAPERS

In 1880 John King began publishing a local newspaper called the *Uxbridge Gazette*, as well as other printing work. Here is his workforce in 1904. A fire at his premises in 1919 led to a merger with another firm.

A second local paper, *The Advertiser*, was printed by Walter Hutchings from his works in Cricketfield Road. After the fire at King's premises the firms joined to form King & Hutchings, and printed the *Advertiser & Gazette*.

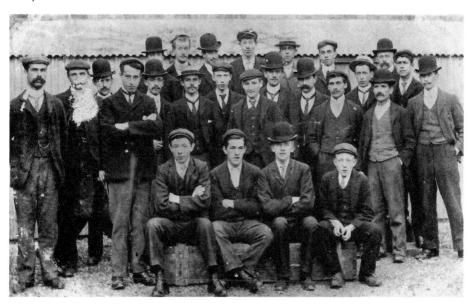

Gazette workers.

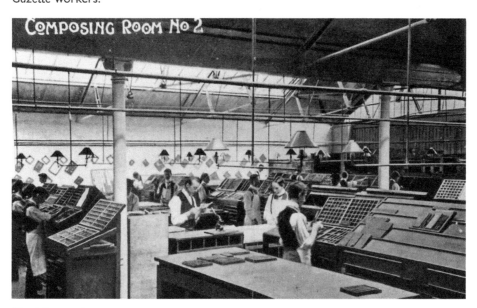

The Advertiser's composing room.

ALFRED BUTTON & SONS

In 1892 Alfred Button took over a grocery shop at No. 33 High Street, and soon took his son Howard into partnership under the name Alfred Button and Sons. This photograph of their shop dates from 1905, but by that time they were developing a strong wholesale side to the business.

In 1911 the firm opened a large depot off Belmont Road and began to deliver groceries over a wide area. Initially their vehicles were all horse-drawn, but in 1912 they bought this splendid Foden steam wagon.

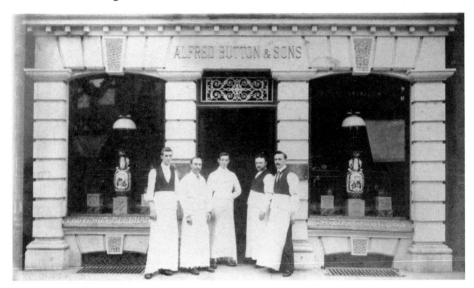

Alfred Button & Sons.

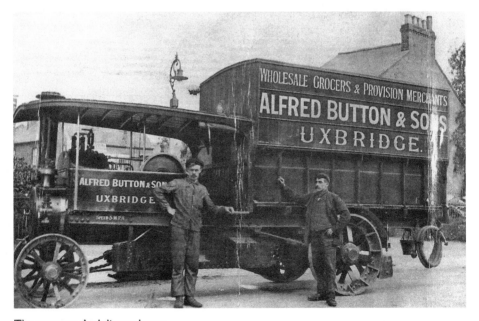

The company's delivery lorry.

POND'S BAKERY

In 1891 Lewis Pond came from Essex to take over a bakery in Windsor Street, and is seen here on a delivery round with his son James. Their hot cross buns, purchased on Good Friday morning, were highly regarded.

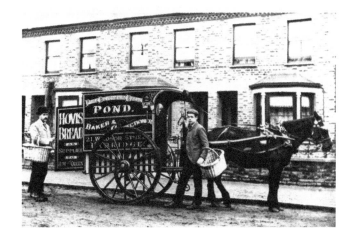

The delivery vehicle for Pond's Bakery.

EDWARD PROCTER

Edward set up business in New Windsor Street in 1896, making carts and wagons of various sizes. The age of the motor car was about to dawn, and soon after this the firm became Procter's Motors and moved into the High Street.

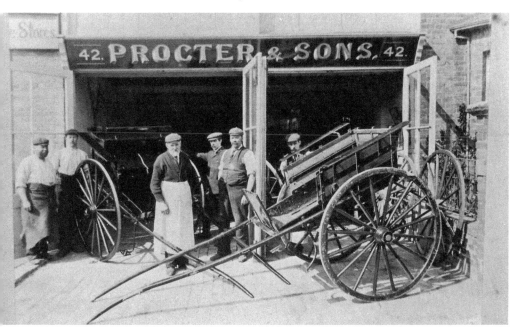

Proctor & Sons.

THEOBALD'S

Theobald's was based in George Street, but toured the surrounding villages once a week selling paraffin and household utensils. Few homes had electricity, so gas burners and mantles sold well.

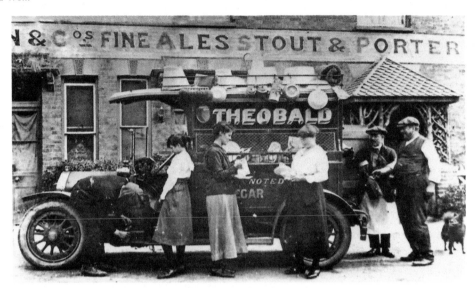

Herbert Theobald's delivery van pictured at Ickenham in 1917.

GREGORY'S

Frederick Gregory was originally a greengrocer and florist, and was Uxbridge's last town crier. Eventually he switched to selling bicycles and cars, and this is a display of early Ford cars in his yard in 1912.

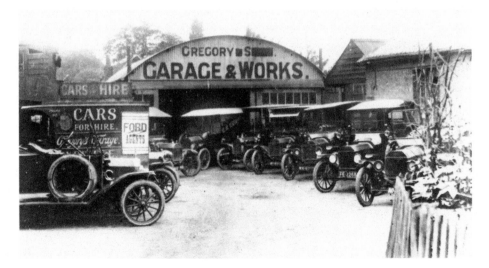

Gregory's Garage & Works.

A NEW OCCUPATION

The advent of the motor car led to the arrival of a new occupation – chauffeur. A local doctor, Ambrose Charpentier, purchased a 3.5 horse-power Benz Velo in 1900 and employed young William Ing to drive it for him. The vehicle had solid tyres and there were real candles in the lamps.

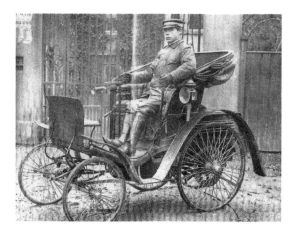

A new occupation: the chauffeur.

LORD HILLINGDON

At this period Lord Hillingdon was living in Vine Lane. His family were very wealthy due to their banking connections. Here is Lord Hillingdon's car about 1918, with William Maynard at the wheel. (The peer's house is now the American School.)

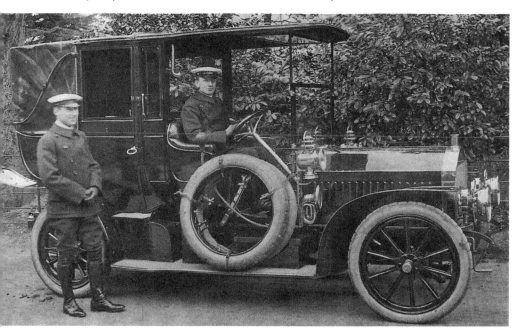

Lord Hillingdon's car.

HILLINGDON HOUSE ESTATE

In 1915 the government acquired the Hillingdon House estate on the outskirts of the town, which became a convalescent home for Canadian troops. In 1917 there was a change of plan and the site was transferred to the Royal Flying Corps. They moved in over the winter of 1917–18.

The estate was to become the Armament and Gunnery School, and here we see the men practising on the firing ranges. In April 1918 the RFC was renamed the Royal Air Force; they remained on the site for over ninety years.

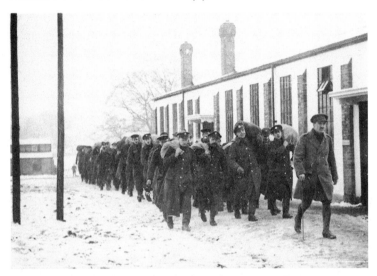

Left: Airmen arriving in the snow.

Below: Men practising on the firing ranges.

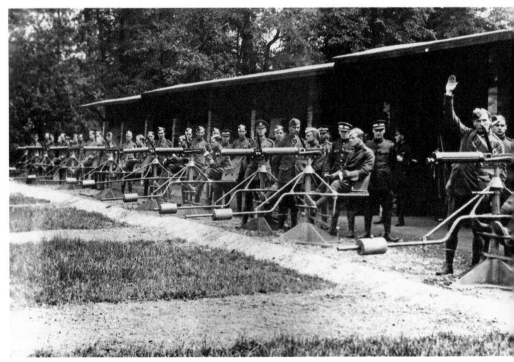

BETWEEN THE WARS

M arket House was decorated for George V's silver jubilee, and two years later for the coronation of George VI. In many parts of the country this period was difficult, with economic depression, unemployment and strikes. The Uxbridge area seems to have suffered little, with commercial and residential developments taking place. The whole district of North Hillingdon came into being in this interwar period.

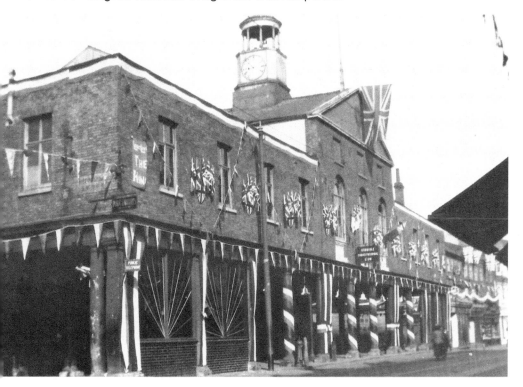

Market House, 1935.

BELL PUNCH CO.

In 1919 the company moved into Upper Colham Mill, an island site on the River Colne to the south of Uxbridge. The company had been founded in London in 1878 and made a hand-operated ticket punch with pre-printed tickets. This system had been adopted by many bus companies in this country.

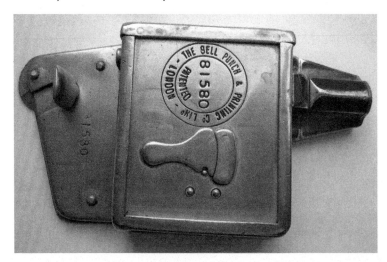

Bell's hand-operated ticket punch.

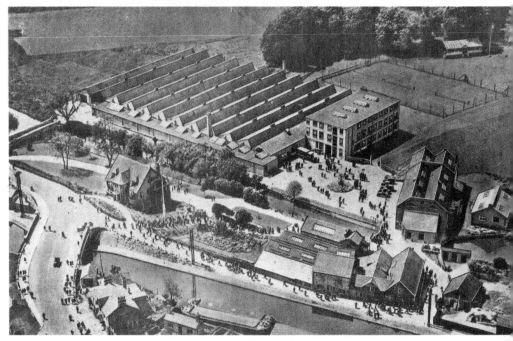

This aerial photograph of 1929 shows the company is well established, with printing works and a Sports and Social Club. Two other companies, Automaticket and Control Systems, were acquired, and there were over 400 employees. By 1932 they were the biggest printer of tickets in the world.

TOTALISATORS

In 1929, after talks with the Racecourse Betting Control Board, a totalisator machine was developed, which became standard in this country and abroad – around 10,000 were sent to the USA.

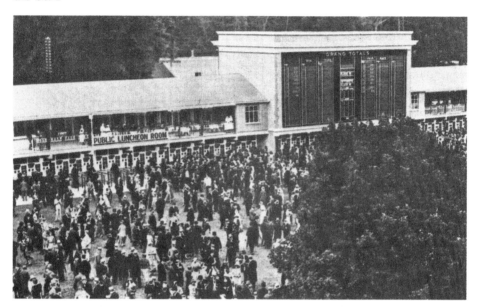

This photograph shows the totalisator by the Ascot paddock in 1933.

TAXIMETERS

In 1931 the small company Waddington Taximeter Co. was taken over and the Bell Punch taximeter was established. It was the only company in the country manufacturing these machines. Around the same time an adding machine called Plus was introduced.

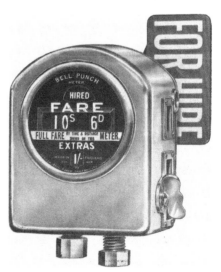

The taximeter.

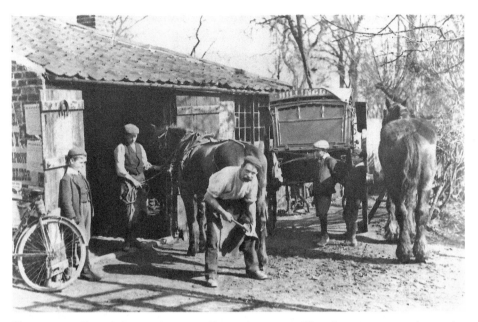

There was still much horse-drawn traffic on the streets. This charming scene shows the forge by the Fox and Geese at Ickenham. Charlie Tappin is shoeing the horse of Matthew Newman, a local baker.

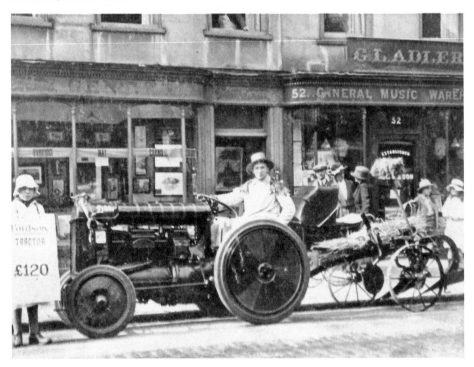

In 1922 a brand-new Fordson tractor was halted outside Wilkinson's Ford depot in the High Street. In 1921 the company had been taken over by A. Norman Reeves, a native of Margate. In the years following, Norman Reeves Motors became a large business.

THE CANAL

Commercial traffic – coal and timber in particular – was in a healthy state. This scene was taken just north of Cowley Lock by the Iver Lane Bridge. Canal boats were still being made at the Fellows, Morten and Clayton yard, off Waterloo Road.

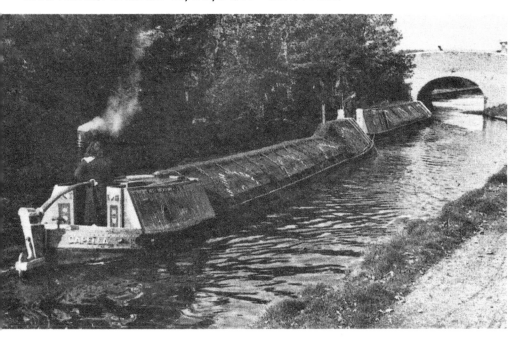

A canal scene.

HARMANS BREWERY

Harmans Brewery, founded by George Harman in 1763, supplied beer to public houses over a wide area, many of which they owned. This trade card dates from the mid-1920s.

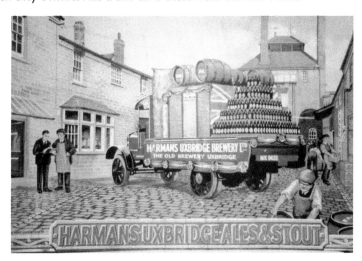

A Harmans Brewery delivery lorry.

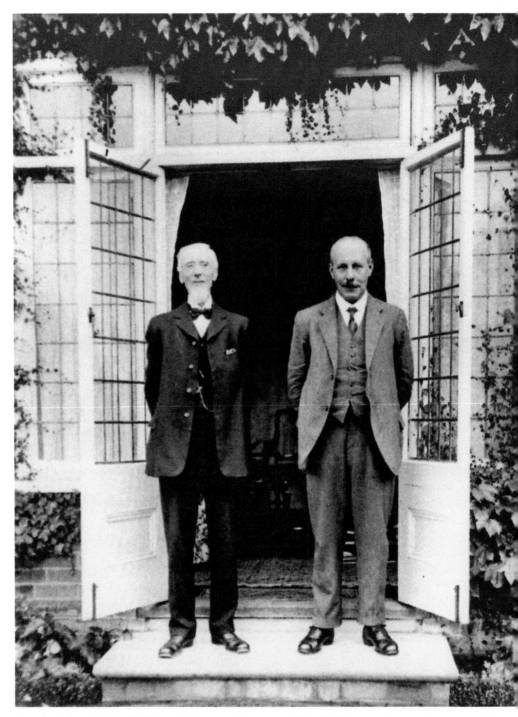

Joseph Lowe (1844–1929) and George Shawyer (1864–1943) are pictured here outside Mr Lowe's house. By 1922 their nursery extended to 120 acres and employed 500 people. The main crops were roses, chrysanthemums, sweet peas and spring bulbs. In 1925 the nursery was described as 'Britain's biggest greenhouse range'.

CARNATIONS

After Lowe's death, Shawyer decided to cease growing roses and instead switch to carnations. Here we see a bank of twenty-two new greenhouses being constructed for the crop on the south side of Cleveland Road.

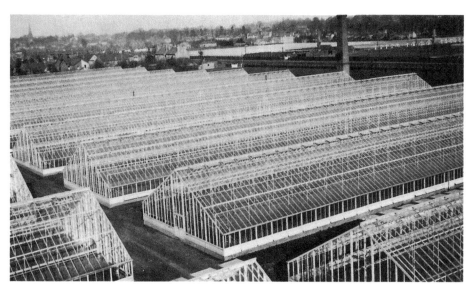

Greenhouses.

THE LAUNCH

Employees pose with bunches of carnations when they first became available. By the mid-1930s the nursery extended to almost 200 acres and employed over 1,000 people full time. Around 50 million blooms were sold annually.

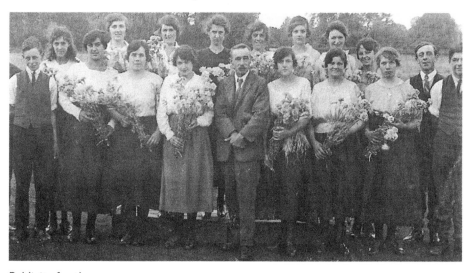

Publicity for the new crop.

CRISIS AT BROWNIE'S

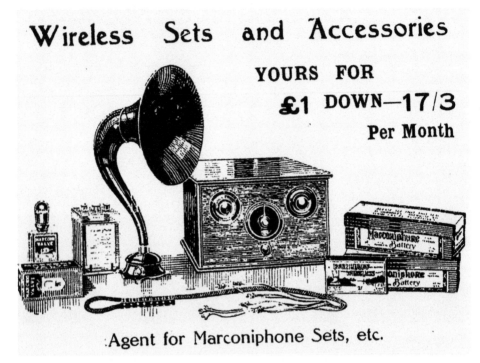

After the First World War the old firm of Brownie's found that sales of agricultural equipment fell rapidly. Farms and fields were being replaced by bricks and mortar. In an attempt to stay in business, the firm began to stock the latest wireless equipment, as this 1929 advertisement shows.

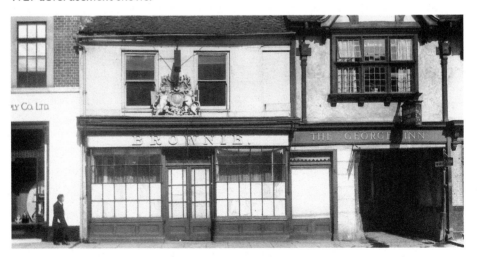

In 1935 we see that the door is shut, the blinds are drawn, and over a hundred years of trading have come to a close. The royal coat of arms remains forlornly over the door. The shop window was the last in the town to have only small panes of glass.

QUICK WORK

In June 1931 work began on the construction of a new cinema, and by August the steel framework was in place. Financiers A. E. and D. A. Abrahams had employed the architect E. Norman Bailey to design the building, which opened on Boxing Day, having been completed in just six months.

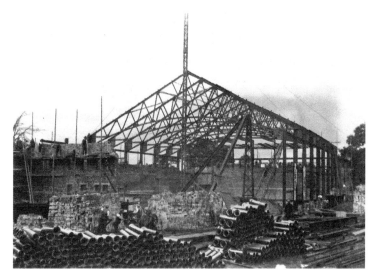

Building framework.

REGAL CINEMA

The interior was an outstanding example of art deco work. There were 1,770 seats, with no gallery. A Compton organ with a detached console was played during the intervals between the films. Outside was a car park for 300 vehicles, and there was a grand restaurant over the entrance hall.

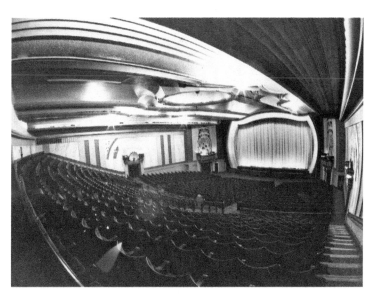

Regal Cinema.

FISH AND CHIPS

In 1909 Jack Hutton (1882–1960) opened a fried fish shop in Windsor Street. It proved a great success and within a short time it was developed into a chain of over thirty shops, including the one shown here near the Regal Cinema. The design of the frontage was very much of the period.

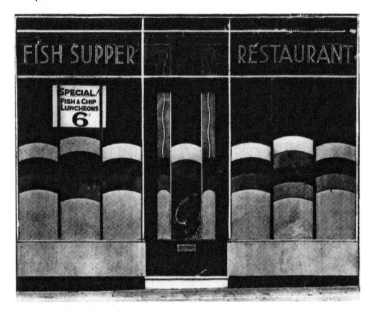

One of Uxbridge Fisheries Ltd's shops.

ADVERTISING

Hutton's company, Uxbridge Fisheries Limited, also supplied wet and dry fish and poultry, and they also were dealers in game, and ice merchants. Their 1931 advertisement played on the saying that fish was brain food. The firm claimed to get their fish from Hull, Grimsby, Lowestoft and Milford Haven.

FISH and BRAINS

The Value of Fish as an ideal food for those of weak digestion or suffering from the strain of modern life, is a proved scientific food fact. We supply the best quality only at prices that are most reasonable.

Supplies from Farm, River, Sea or Forest.

An Uxbridge Fisheries Ltd advert.

KIRBY BROS

In 1913 the brothers Robert and Frank Kirby opened a small hardware shop in the High Street. The First World War broke out almost immediately and both brothers served in the army, but the business survived. In the 1920s it expanded rapidly and, with mergers and takeovers, became a large firm of builders' merchants.

In 1932 Kirby's claimed that the distance covered annually by their vehicles was over five times round the world, that the fireplaces they made would cover the Wembley Stadium pitch nine times over, and that the rainwater and gutter pipe they'd sold would reach from Paddington to Reading.

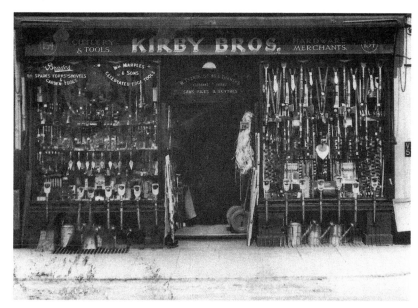

Kirby's shop.

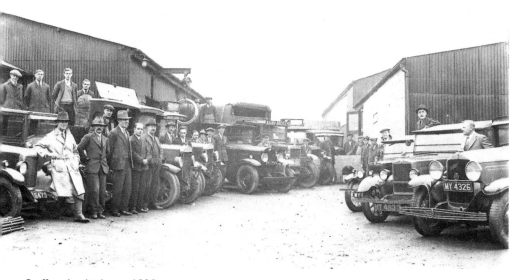

Staff and vehicles in 1930.

FILM STUDIOS

In 1935 London Film Productions acquired an estate at Denham, and built these studios along the North Orbital Road. Filming began in 1936. Pinewood Studios opened in 1936, 4 miles to the south, at Iver Heath. Both offered employment to people in the Uxbridge area.

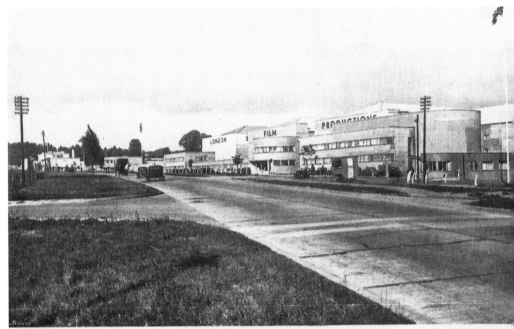

Copyright]

Denham Studios, Uxbridge

[Ed. J. B. & Co. Lt

Denham Studios.

TROLLEYBUSES INTRODUCED

In November 1936 trams gave way to trolleybuses. The route was No. 607 and ran from Shepherds Bush to Uxbridge, with the vehicles being garaged at Hanwell.

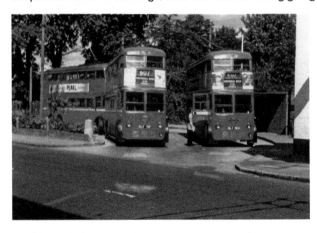

The Uxbridge terminus in the High Street, around 100 yards west of Harefield Road.

MAJOR ROADWORKS

During this period the Western Avenue (later the A40) was being constructed. The old London to Uxbridge road was increasingly congested, and the scheme was designed to bypass the old town centres. This section near Northolt was completed in 1934, and in the late 1930s the road reached the Uxbridge area.

Road-widening schemes were also needed in Uxbridge itself; for example, Vine Street, which was widened at the High Street junction in 1938.

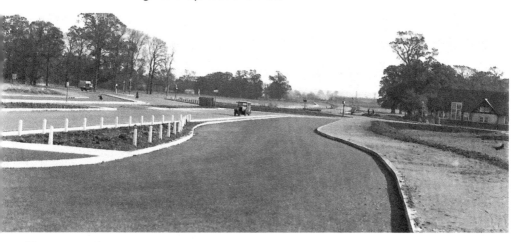

The new road.

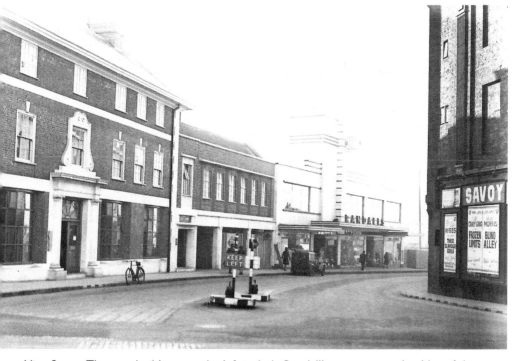

Vine Street. The new buildings on the left include Randall's store, opened in May of that year.

BELMONT ROAD STATION

In 1933, when the Piccadilly line trains joined the Metropolitan ones on the Uxbridge branch, it became apparent that the existing station was inadequate. London Transport found a new site in the High Street, and work began in 1936.

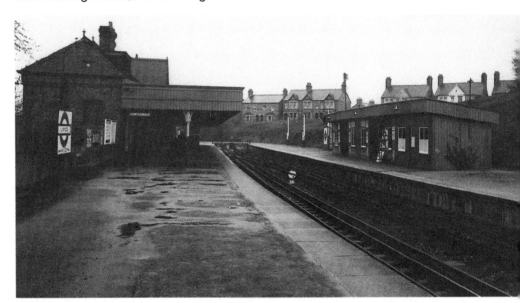

Belmont Road Station.

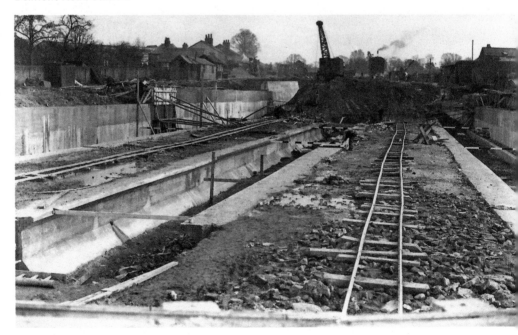

Work proceeding on the new station in 1937. During the excavations, the tusk of a mammoth was found 14 feet below ground level. Experts dated it from the last Ice Age – around 10,000 BC.

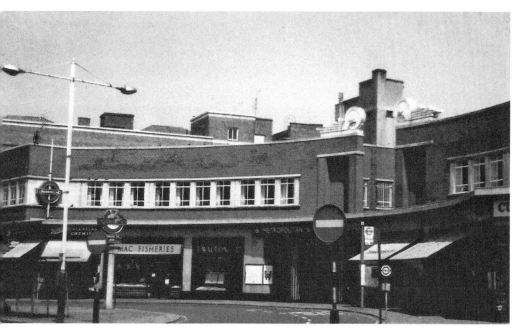

The station opened on 4 December 1938. It was set back from the High Street, thereby giving a large open area in the town centre. The architect was Charles Holden, and the building is now listed as being of architectural interest.

The abandoned station was not demolished but was taken over by Alfred Button & Sons, the wholesale grocery firm next door. This 1965 photograph shows the old building being used as extra storage.

OUTBREAK OF WAR

During the war many local firms took on government work, especially those involved in engineering. At Norman Reeves Motors, with most cars off the roads, they began to maintain and overhaul Bren Gun Carriers for the army.

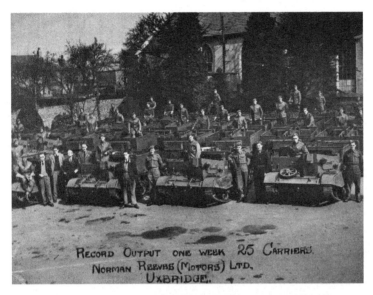

Bren Gun Carriers.

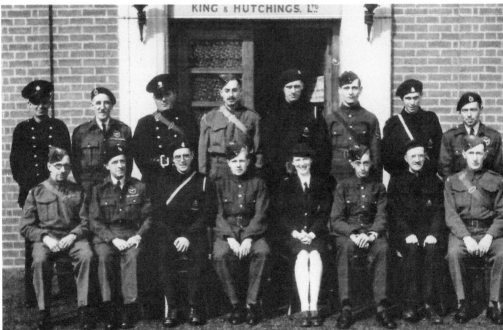

A group of staff at the King & Hutchings printing firm have clearly taken on civil defence work as well as their ordinary jobs. Identifiable here are the uniforms of the Air Raid Precautions service, the Home Guard, the Fire Brigade, the Red Cross, the Observer Corps and the Air Cadets.

POST-WAR CHANGES

When the war ended large parts of the old market town remained intact, including the old inn the Chequers, which remained in business. For some years food rationing continued, there was a shortage of building materials, and money was short. Eventually things settled down and, when they did, changes came thick and fast. Whole areas of the town were cleared and redeveloped, old shops and businesses were replaced, and high-rise buildings rose from the rubble.

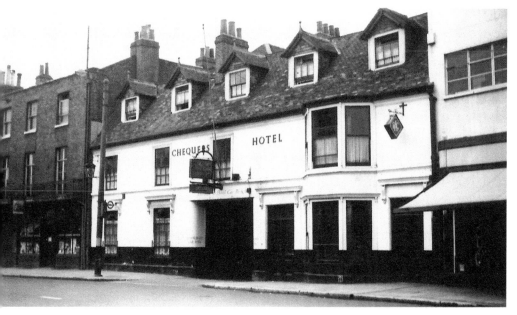

The Chequers Hotel.

LAUNDRY YARD

In the yards and alleys off the main street, many old buildings, stables and workshops were still in use. The building in the distance of the image here, with the tall chimney, began life in Victorian times as a brewery. It had become Uxbridge Sanitary Laundry.

The laundry yard can be seen in the distance.

RAYNER'S THE CHEMISTS

This charming shopfront displayed carboys containing coloured liquid, and the shop dispensed its own medicines. Inside there were shelves labelled 'Horse and cattle medicines', but on the shelves were modern deodorants. Trading ceased in 1960.

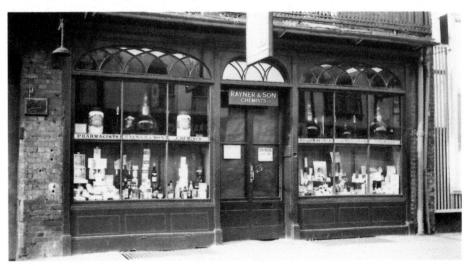

Rayner's.

MILK DELIVERY

A number of tradesmen still had horse-drawn vehicles, although the Express Dairy float shown in the image here had been decorated for a charity procession. The dairy had a depot close to the town centre, but horses had gone by 1960.

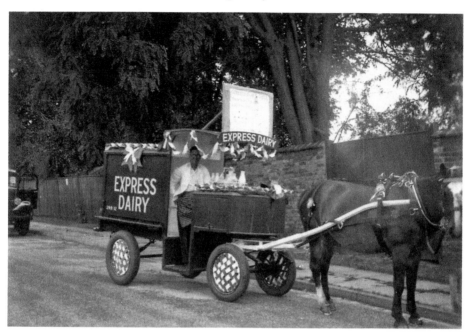

The Express Dairy float.

FOUNTAIN'S MILL

Corn was still being brought in via the canal, seen here on the left. Frays River, on the right, was driving the mill machinery. In 1954 the mill was bought by Glaxo, but a fire soon afterwards disrupted operations. Closure came in 1961.

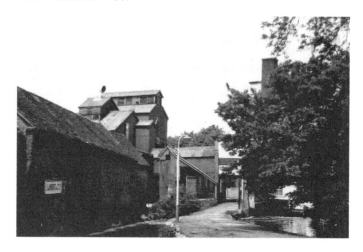

Fountain's Mill.

THE GASWORKS

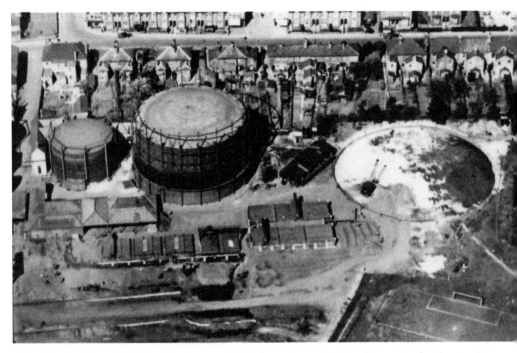

An aerial view from 1954 showing that work had started on a third and larger gasholder to cope with increased demand. Earlier holders were erected in 1922 and 1932, but this one was 150 feet in diameter and rose to 120 feet. The houses at the top of the picture are in Cowley Mill Road.

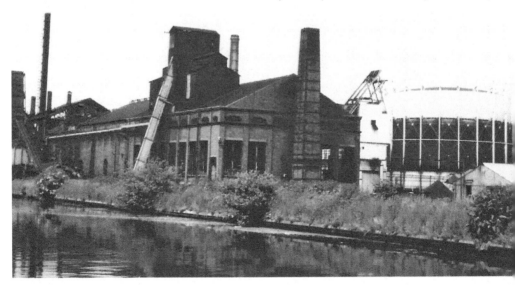

The arrival of natural gas changed everything. The manufacture of gas ceased here in 1968, after the conversion of existing appliances. The gasholders were demolished in the year 2000, and work began on turning the site into a trading estate.

UXBRIDGE TRADING ESTATE

In 1949 Uxbridge Council decided to develop a 20-acre site, off Cowley Mill Road, as a trade park. In the early twentieth century part of the site had been the local sewage works. By 1965 over fifty firms had settled there, employing about 1,500 workers. Most were involved in light engineering.

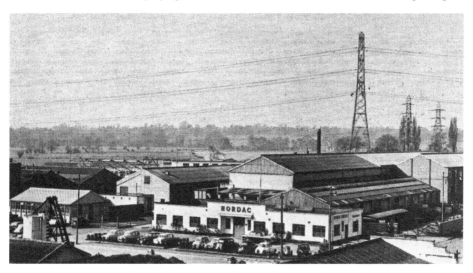

The trading estate off Cowley Mill Road.

NORDAC LIMITED

Nordac were manufacturers of chemical plant and corrosion resistant equipment. Other firms on site included Trimite Ltd, specialist paint manufacturers, and Monkton Motors, who produced bulk liquid transporters.

Nordac offices.

HARMAN'S BREWERY

The brewery, a public company since 1924, continued to produce a variety of bottled drinks and supply them over a wide area. In 1962 the firm was taken over by Courage. Two years later they closed it down.

In 1953 Harman's introduced Garland Ale to mark their 200th anniversary and the Queen Elizabeth II's coronation. To advertise the new product at the annual Uxbridge Show they obtained the services of comedian Norman Wisdom.

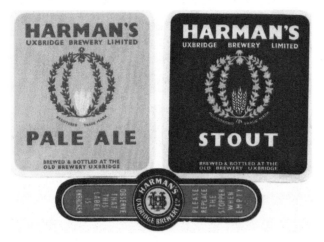

Left: Harman's labels.

Below: Norman Wisdom promoting the new Garland Ale.

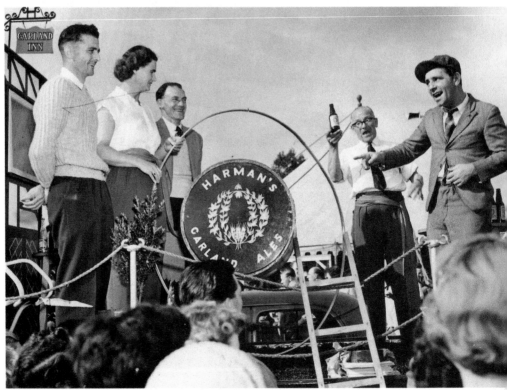

JACK EDWARDS

In 1954 Mr Edwards and a colleague, Mahmoud Ali Abdo, bought a small hardware shop just off Windsor Street and called it Mahjacks. Mahmoud soon left, but Jack Edwards developed the business into a major DIY store, gradually taking over adjoining premises.

By 1983 the original little shop had long since disappeared. The firm built up a strong reputation in the district, with plumbing and timber departments giving excellent service.

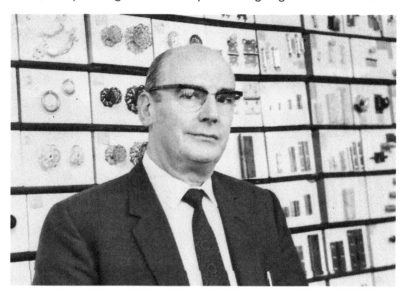

Jack Edwards.

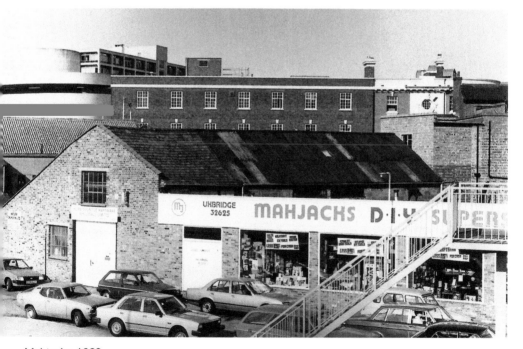

Mahjacks, 1983.

SHAWCRAFT LTD

Hundreds of people pass No. 69 Rockingham Road every day and don't give it a second glance. No blue plaque adorns the wall. Yet it is the birthplace of the Daleks, the terrifying creatures from *Doctor Who*.

In 1960 the premises were occupied by model makers Shawcraft Ltd, who were given the job of making the prototype, although later models were made elsewhere. The Daleks first appeared on television in 1963, and began their task of 'extermination'.

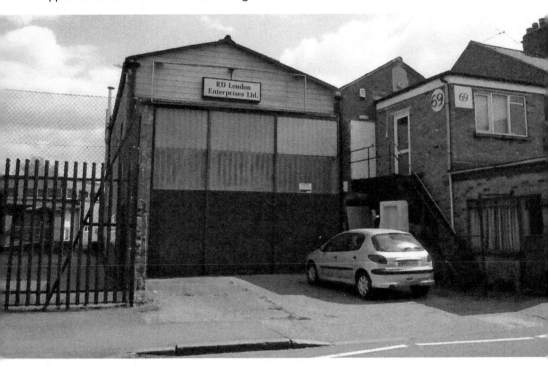

No. 69 Rockingham Road, birthplace of the Daleks.

TRAVELLING TRADESMAN

Everything sharpened on your doorstep! With a grindstone on a decorated handcart, the tradesman sharpened knives, shears and other implements. Once a regular visitor, he was not seen after 1973.

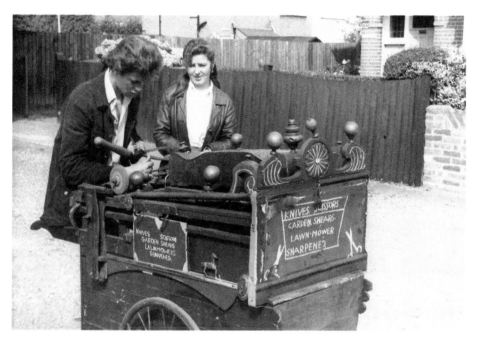

A travelling tradesman.

ANITA MARK VII

The world's first electronic desktop calculator was produced at the Bell Punch factory in 1961, and work on pocket calculators followed. After the rearrangement of company structure, the firm left Uxbridge in 1976, and the site was sold.

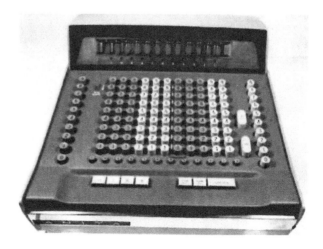

The Anita Mark VII.

ROBERT LEE LTD

The firm of Robert Lee Ltd, suppliers of beekeeping equipment, came to Uxbridge in 1912. The machine shown here produced sheet beeswax, which was placed in the cells of the hive to encourage the bees to breed and produce honey. By 1975 the firm's products were being exported to around twenty countries.

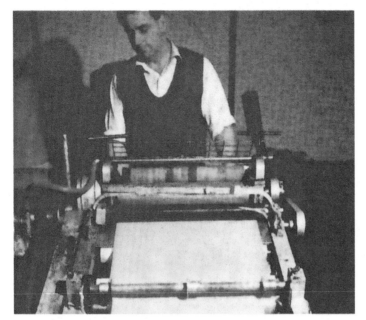

Left: Beeswax machine.

Below: A consignment of red cedar arrives at Lee's Uxbridge headquarters. This wood was used in the making of beehives since it is weather-resistant. The firm left the town in 1981, and closed soon afterwards.

LOWE AND SHAWYER

By 1955, millions of blooms were still being sold each year, but because of old-fashioned methods, ageing equipment and ineffective management, the number was falling. The firm went into voluntary liquidation in 1958.

Almost all of the former nursery land became the home of Brunel University, which had begun life as Acton Technical College. Brunel gained its charter in 1965.

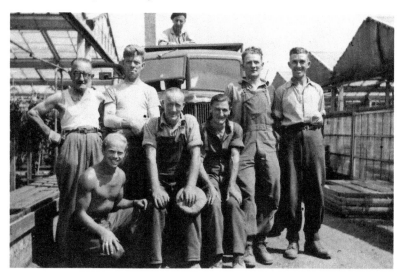

Workmen at the cut-flower nursery in 1955.

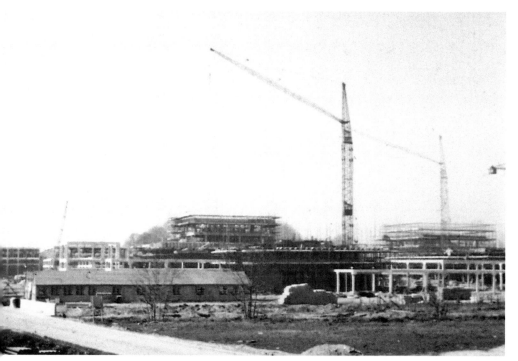

Phase one of the development of Acton Technical College, later Brunel University.

GREEN SHIELD STAMPS

A promotional scheme was set up by Green Shield, whereby shoppers were given stamps with their purchases. When they had the sufficient number, they were able to claim a gift. The Uxbridge gift shop was open from 1973–77. The scheme eventually collapsed, and trading ceased in 1991.

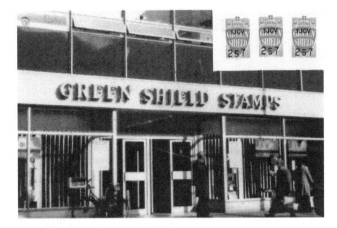

Green Shield.

PEARCE'S FISH SHOP

Cecil and Lucy Pearce ran a fish shop in Windsor Street, which was started by Cecil's grandfather in 1865. They never owned refrigerators, instead ice was delivered regularly. They retired and closed the business in 1970.

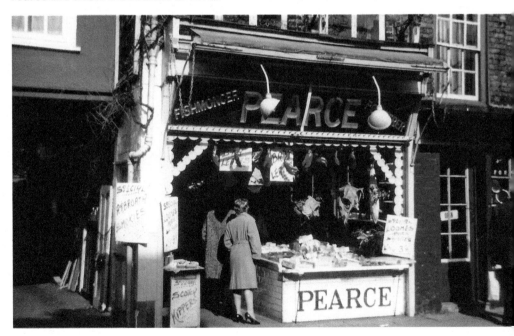

Pearce's Fish Shop.

LOCAL SHOPS

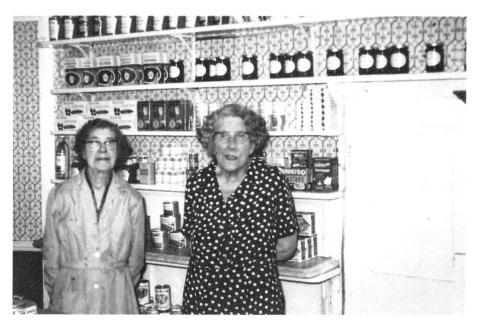

Nellie Sherwin and her assistant Florrie Dawson can be seen here in their High Street shop, Sherwin's. Nellie's father had founded the business as a dairy in 1873, but from 1943 it became a grocery store. They closed in 1971 after a Tesco store opened opposite.

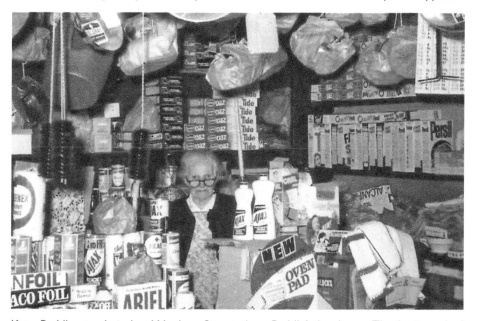

Kate Peddle stands in her Windsor Street shop, Peddle's hardware. The business had been started around 1850 by her grandfather, John Peddle. Kate decided to retire in 1972, aged seventy-three. Another historic shop had gone.

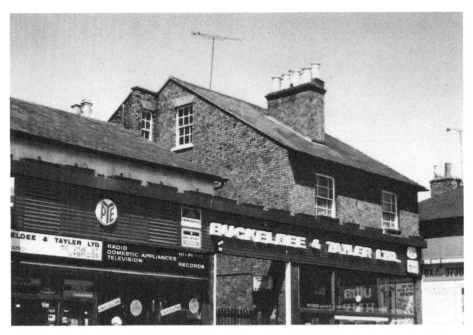

John Buckledee and Arthur Tayler set up in business in 1924 as plumbers and electricians, but they later moved into radio in Vine Street. John's sons, Bob and Bill, later traded in TV, domestic appliances, records and Hi-Fi equipment. They went into voluntary liquidation in 1977.

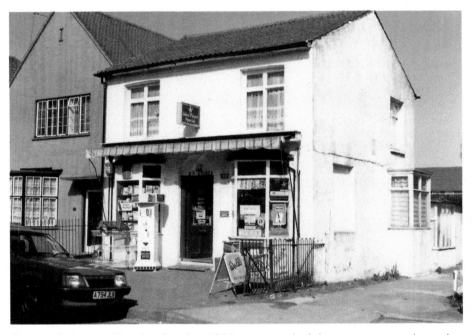

This small shop in Waterloo Road in 1984 was typical of the many corner shops that once opened all hours and served the immediate area. They were usually owned and run by a family who lived on the premises, but one by one they have disappeared.

H & B ANTIQUES

Ellen Hatcher started her business in 1959, but 'antiques' was rather a grand name for a business based on house clearance. Nevertheless, it was a place where one might find a bargain.

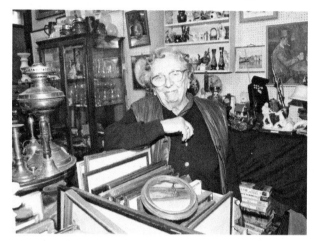

Ellen Hatcher is seen in her bric-a-brac shop in Cowley Road.

OUTSIDE THE SHOP

The front of Ellen's shop was equally congested and, of course, everything had to be put out and brought in daily. Ellen recalled a visit from singer Adam Faith on one occasion, when she was interviewed upon her retirement in 1998.

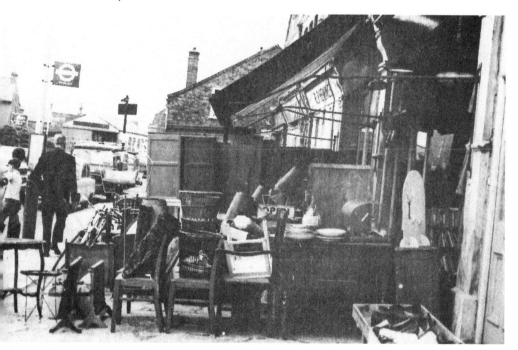

The front of Ellen's shop.

HARMAN HOUSE

History was made in October 1985 when the town's first high-rise office block was opened, named after the brewery that formerly occupied the site. It dominated the town, and dwarfed the humble council houses nearby.

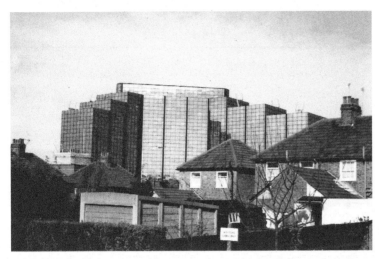

Harman House.

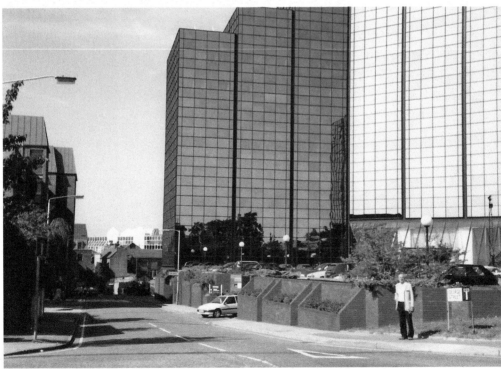

Harman House, seen from the top of George Street. Some locals nicknamed it 'Dallas' and others appreciated the reflection of the sky on the glass. Hewlett Packard were the first occupants, but they only stayed a few years.

OFFICES GALORE

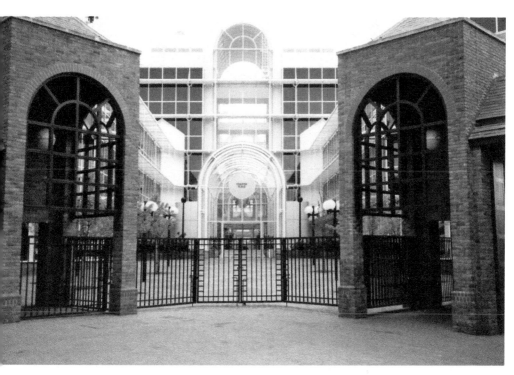

Charter Place was erected in 1986–87 at a cost of £30 million and occupied a site between Windsor Street and Vine Street. From 1988–2013 most of the building was occupied by Coca-Cola Schweppes, but they moved to Enterprise House in York Road. By the time Charter Place was ready, Uxbridge was close to three motorways – the M4, M25 and M40. It was 4 miles from Heathrow Airport and on the London Underground system. Conditions were set for office development.

CIVIC CENTRE

The London Borough of Hillingdon came into being in 1965, and it soon became apparent that an administrative centre was needed. It was decided to build a Civic Centre, incorporating the existing Middlesex County offices. In 1975 work was underway.

The architects were Robert Matthew, Johnson-Marshall & Partners. Some departments had moved in by 1976, and the official opening was in 1979.

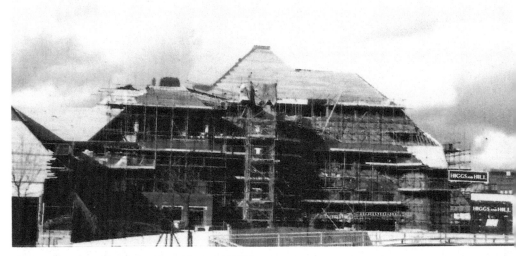

Construction work on the Civic Centre, 1975.

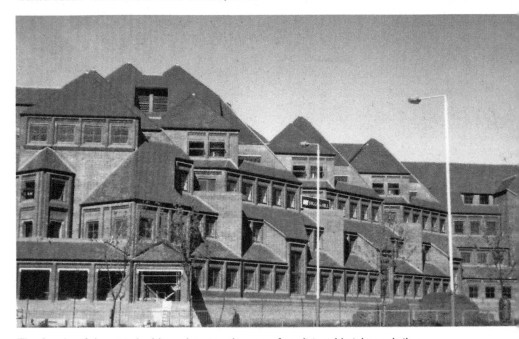

The façade of the civic building, showing the use of traditional bricks and tiles.

VALIANT HOUSE

This five-storey block at the junction of the High Street and Park Road was opened in 1986. It was designed to harmonise with the Civic Centre nearby. Part of the building has been occupied by HM Revenue & Customs for some time now.

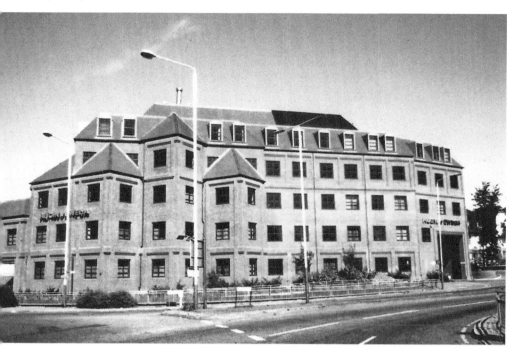

Valiant House.

BELMONT ROAD OFFICES

This edifice was opened by the governor of the Bank of England in January 1989, and was mostly occupied by the Allied Irish Bank. Another part became JobCentrePlus.

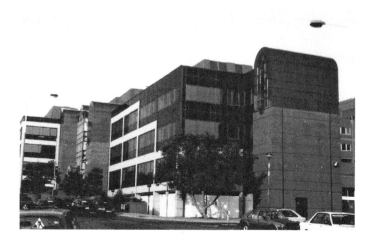

Offices along
Belmont Road.

LOVELL HOUSE

Built in 1983–84, the building was initially used by Lovell Construction as their head office. Being next to the Civic Centre, it was designed to blend with the appearance of those council offices.

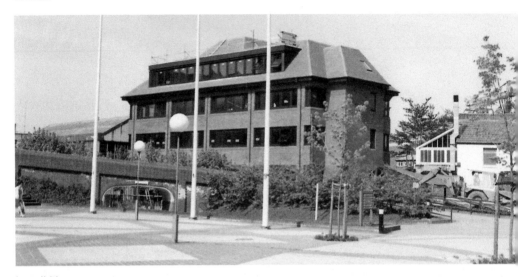

Lovell House.

ONE YORK ROAD

Standing at the junction of Belmont Road and York Road, this was known initially as York House. It later became Pansophic House – after the computer firm that was there. After refurbishment it has acquired a third name, One York Road.

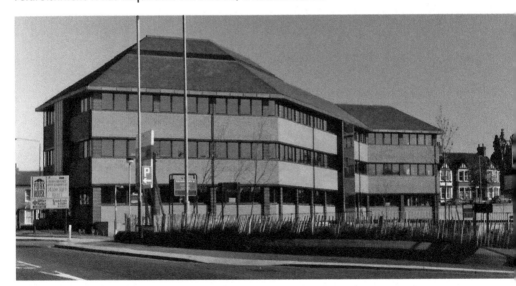

One York Road.

JAK'S

The fish and chip shop in Hillingdon Road was formerly the Green Man public house, but like many other similar establishments it was losing money. In 1994, it was given a new lease of life by a change of use.

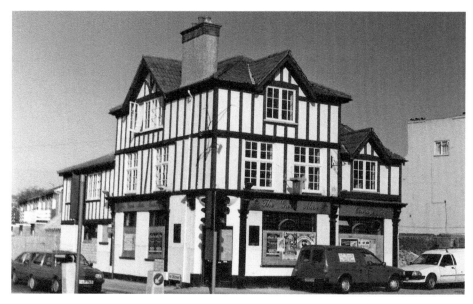

Jak's.

ROYAL MAIL

By the 1980s, it was clear that the existing Post Office facilities in Windsor Street were inadequate for modern use. This canalside site, off Cowley Mill Road, was ready in 1990.

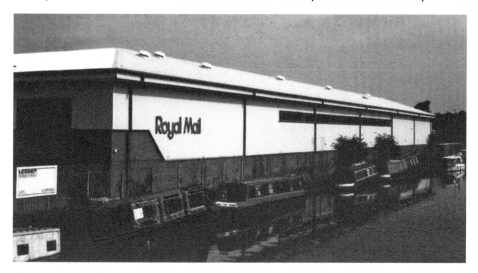

The new Royal Mail site.

THE QUAYS

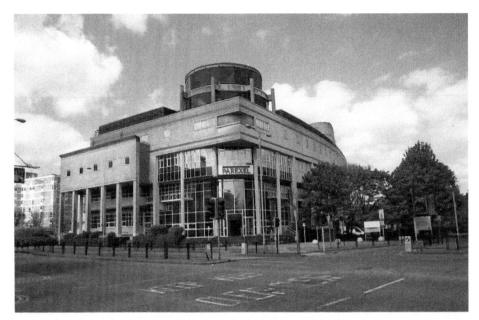

The Quays: an office building that was completed in Oxford Road in December 1991. Insurance company Lincoln International moved in until 2001, after which Parexel International, a clinical consulting firm, have moved in.

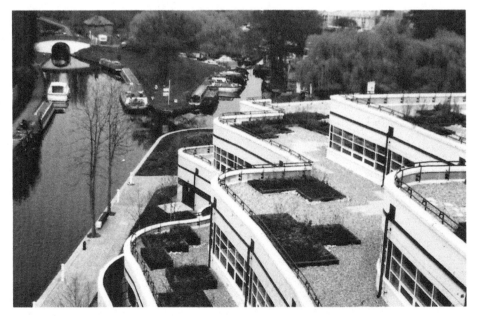

A view from the roof of The Quays shows terraced gardens sloping down to the canal at the rear of the building. The white bridge by Uxbridge Lock can be seen, and, in the middle distance, Denham Marina.

THE BUS GARAGE

In 1983 a new bus garage came into use, being the basement of an office block off Bakers Road. This led to the closure of the old bus garage in the Oxford Road at Denham.

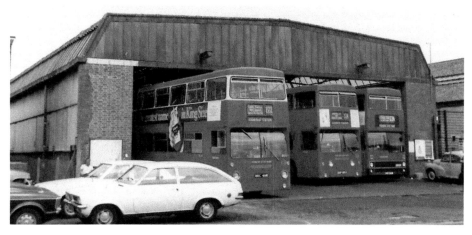

The old bus garage.

FILMS

A lot of filming has gone on locally, perhaps because Pinewood Studios are not far away. In 1986 cameras were in the Greenway shooting *The Dressmaker,* with the camera on a tower to film an interior scene. The story was based on a Beryl Bainbridge novel.

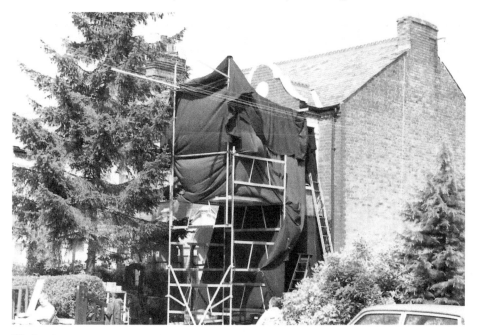

Filming in progress.

MAHJACKS

The branch finally closed in December 1994. Their original premises had been lost to redevelopment, and this small building was all that was left. To this day, though, the adjacent road is unofficially called 'Mahjacks Roundabout' by local people.

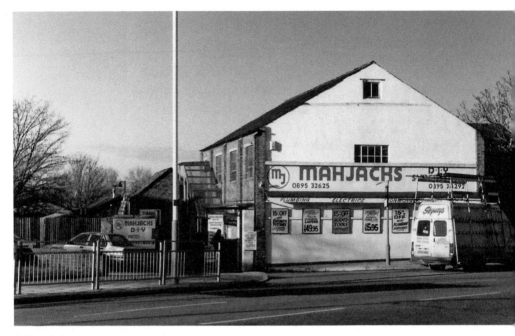

Mahjacks.

THE CEDAR HOUSE

This property in Hillingdon village is an Elizabethan mansion with later additions. In the post-war years it became a boys' preparatory school, but when that closed it became offices.

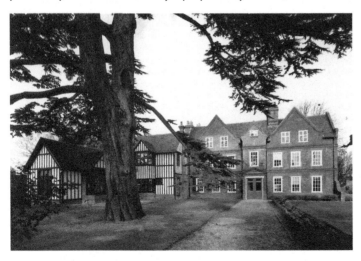

The Cedar House.

THE ATRIUM

An office building completed in 1990 on the site of the town's first Odeon cinema. BP Exploration formerly occupied part, but PriceWaterhouse Coopers are among the tenants today.

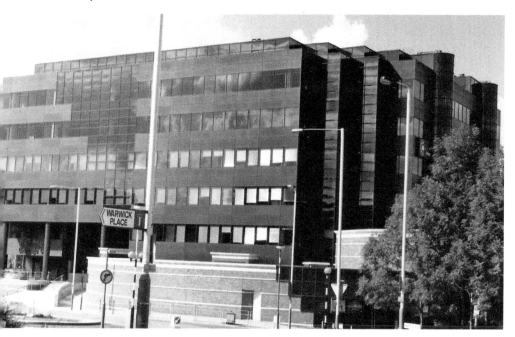

The Atrium.

THE NEW ODEON

A new Odeon cinema was incorporated in the Atrium complex. It contained two screens, which had 230 and 440 seats. It closed in March 2001 on the opening of Odeon III in the Chimes shopping mall.

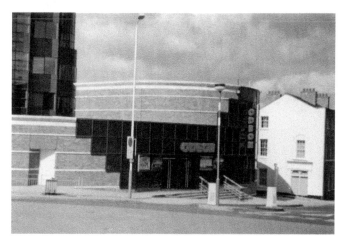

The new Odeon.

ELECTRICITY

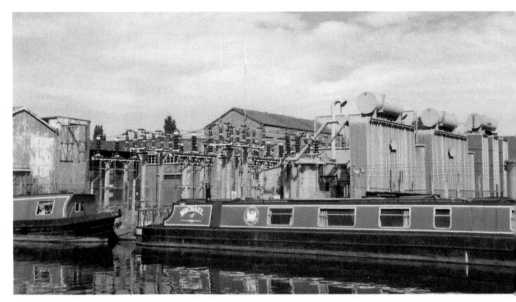

The first electrical power was generated in Waterloo Road in 1902 (see page 34), and gradually the Electricity Board occupied much of the road. Pylons reached the end of the road.

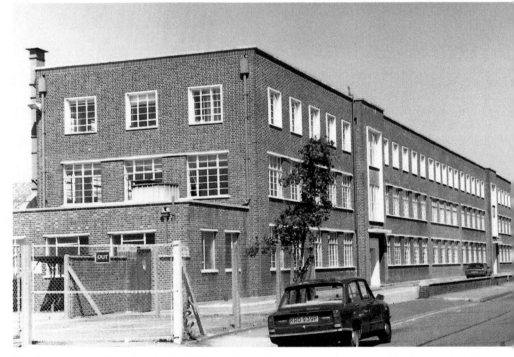

The board revised its plans in the 1990s and transferred operations to its Sandstone site, close by in Buckinghamshire. Here is one office block that was demolished and replaced by housing.

UXBRIDGE BOATYARD

It's a long time since Fellows Morton & Clayton were building boats here, but the yard is still active with repairs and maintenance. The canal is now busy with pleasure craft and there are marinas at Harefield, Denham and Cowley.

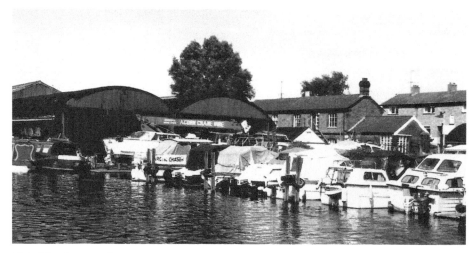

Uxbridge boatyard.

MORE HIDDEN HISTORY

Repairs to the Market House in 1991 revealed grains of corn concealed in the brickwork. Samples were sent to Kew Gardens and experts confirmed it was wheat. It must have been there for over 150 years.

Repairs to Market House.

KINGS MILL

The story of this flour mill – very close to Uxbridge – can be traced back to the Domesday Book. After the war, it flourished, and the large silo in the background was added in the 1960s. Circumstances changed and Allied Mills closed the operation in 2001. A housing development replaced it, although the main block survives as residential property.

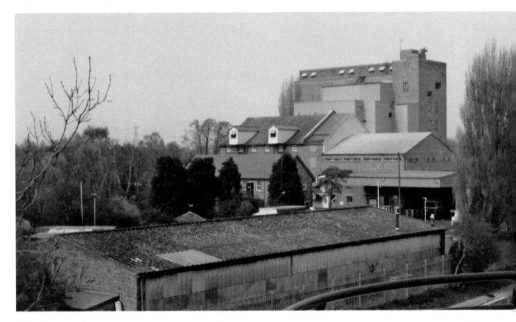

The flour mill.

CAPITAL COURT

This five-storey building, off Mahjacks roundabout, which was completed in 2002, incorporates a restaurant on the ground floor. In 1555 three men were burned at the stake on this site for their Protestant beliefs.

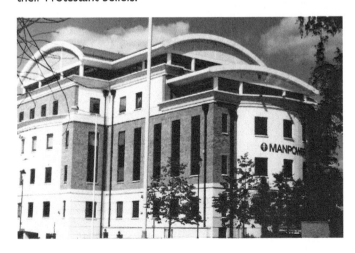

Capital Court.

THE SCENE IN 2017

UPPER COLHAM MILL

After the Bell Punch Co. left in 1976, the site became the Riverside Way trading estate. Among all the modern buildings, this original flour mill survives. The building itself is early nineteenth century, but the history of the mill can be traced back to the Domesday Book. In modern Uxbridge, then, there are still traces of its historic past.

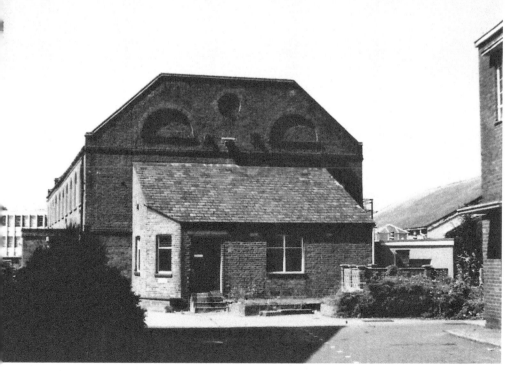

Upper Colham Mill.

UXBRIDGE BUSINESS PARK

Entry to this estate is via Sanderson Road, since it occupies land that was formerly Sanderson's Fabrics factory. Firms on the site today include Cadbury Schweppes and the pharmaceutical giant Bristol-Myers Squibb.

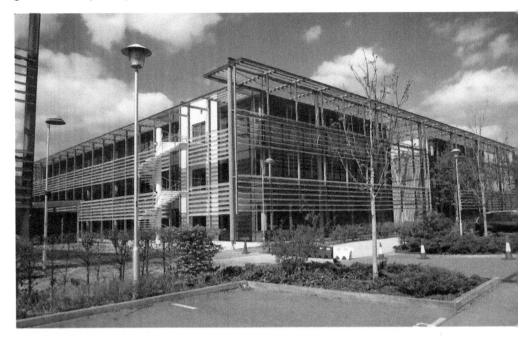

Uxbridge business park.

INTU UXBRIDGE

A shopping centre called The Chimes was opened in March 2001, but the name was changed in 2012 when it was purchased by Intu Properties. Locals preferred the original name, but both are evident on the entrance today.

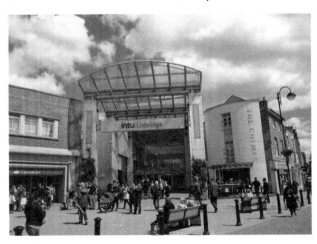

The entrance to INTU.

ALFRED BOVILLE WRIGHT

Alfred came to Uxbridge in 1904 to work as a picture framer and vendor of artist's materials. He was a grandson of the noted artist Joseph Wright, known as 'Wright of Derby'. In 1911 Alfred moved to No. 128 High Street, which had been a private house until then.

Today, over 100 years later, the business continues under the direction of Alfred's grandson, Robert. The shop next door at No. 127 was taken over forty years ago, and there is a branch at Maidenhead.

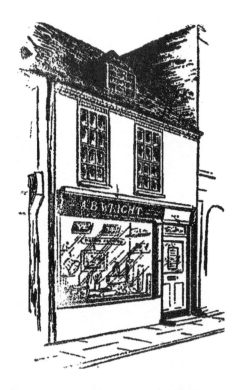

Above left: Alfred Boville Wright.

Above right: This sketch shows Alfred's shop in the early days.

Right: Boville Wright's.

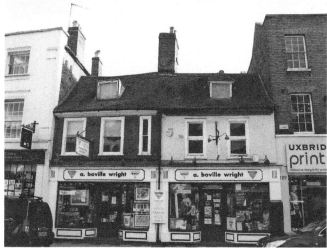

RANDALL'S CLOSURE

There was widespread sadness when Randall's store closed in January 2015 after 124 years of trading, but circumstances had changed and the family decided to call a halt. The site now awaits redevelopment.

The head of the firm had been MP for Uxbridge from 1997–2010. In recognition of his services to Westminster, he was awarded a knighthood.

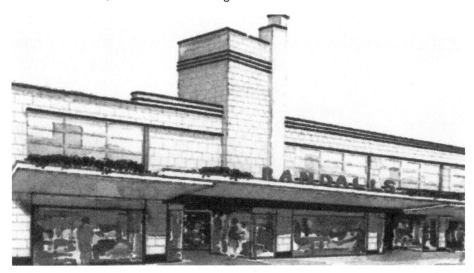

Randall's.

Sir John Randall.

Above left: Brian Martin joined the Windsor Street firm of Mills (the opticians) as a young man. Now, although well past retirement age, he continues to work occasionally, for which his long-term customers are grateful.

Above right: Raymond Puddifoot MBE has been leader of Hillingdon Council since the year 2000 – a notable period in office. With his colleagues, he has brought continuity and stability to local government.

In 2008 the office building at No. 106 Oxford Road was acquired by Bucks New University for their Department of Nursing and Health Care. There are now courses in adult and children's nursing.

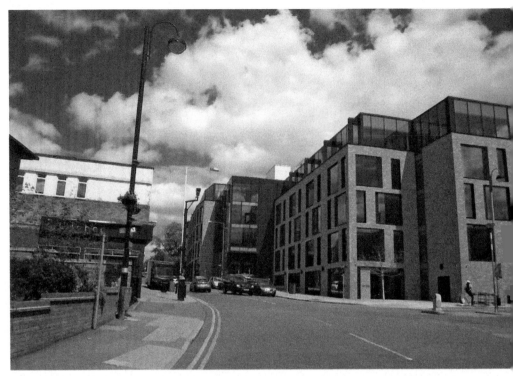

'Belmont' – an office block opened in Belmont Road in 1989 mainly occupied by the Allied Irish Bank (see page 79). In 2015–16 it was completely refurbished and also enlarged by Aviva Investors.

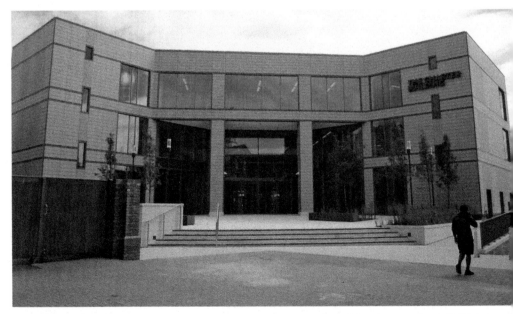

The Charter Building is the new name for Charter Place, the office block built in 1977 (see page 77). Like the one above, it was enlarged and refurbished in 2015–16.

WORLD WAR II BUNKER

RAF Uxbridge was closed in 2010. The main feature was the underground operations room, from which our fighter planes in south-east England were controlled in the Battle of Britain. A model Spitfire, together with a Hurricane, stands near the entrance to the bunker.

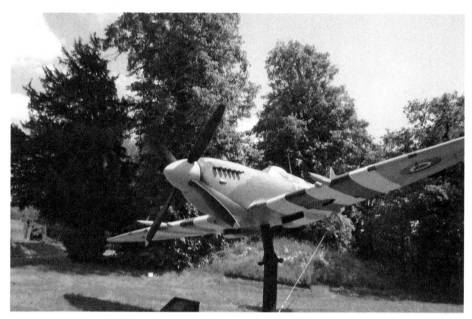

The model Spitfire near the entrance to the bunker.

VISITOR CENTRE

In 2016 ownership of the operations centre passed to Hillingdon Borough, and, with the aid of a government grant, they are now building a visitor centre nearby. The whole area has been renamed St Andrew's Park.

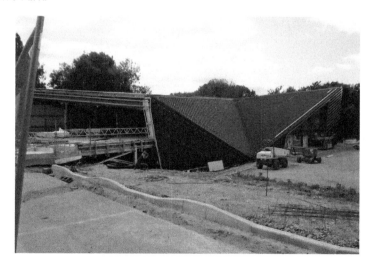

Building work on the new visitor centre.

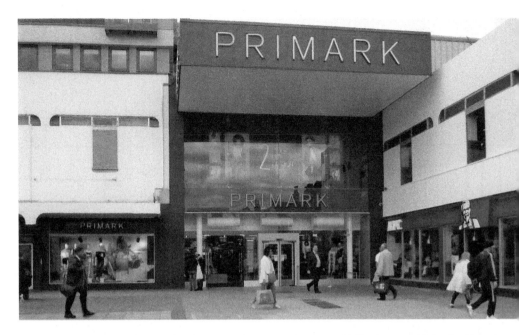

A long queue formed in the High Street one Saturday in February 2017 when the Uxbridge branch of Primark was opened. They have taken over a large section of the Pavilions Shopping Centre.

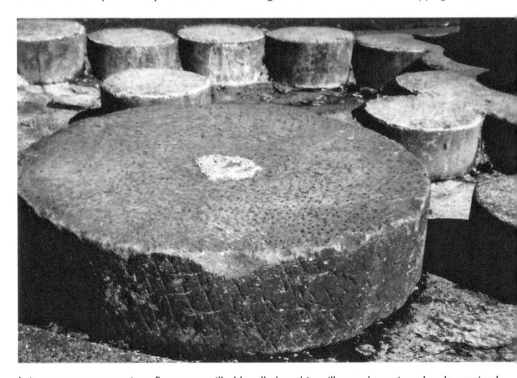

It is many years now since flour was milled locally, but this millstone has miraculously survived. How many children – leaping around in the Fassnidge Recreation Ground – would recognise what it is?